SABLE ISLAND

in BLACK *and* WHITE

JILL MARTIN BOUTEILLIER

NIMBUS
PUBLISHING

Nimbus Publishing Limited
3731 Mackintosh St, Halifax, NS, B3K 5A5
(902) 455-4286 nimbus.ca

Printed and bound in Canada

NB1224

Cover and interior design: Jenn Embree
Cover photo: J. D. Taylor (L), wireless operator, Trixie Bouteillier, and Trixie's Labrador retreiver, Cholo. The wreck of the *Skidby* rests in the background.

Library and Archives Canada Cataloguing in Publication

Bouteillier, Jill Martin, author
Sable Island in black and white / Jill Martin Bouteillier.
 (Images of our past)
 Includes bibliographical references and index.
 ISBN 978-1-77108-381-2 (paperback)

1. Sable Island (N.S.)—History—Pictorial works. 2. Sable Island (N.S.)—
History. I. Title. II. Series: Images of our past

FC2345.S22B68 2016 971.6'99
 C2015-908194-7

Canadä Canada Council Conseil des arts
 for the Arts du Canada

Nimbus Publishing acknowledges the financial support for its publishing activities from the Government of Canada through the Canada Book Fund (CBF) and the Canada Council for the Arts, and from the Province of Nova Scotia. We are pleased to work in partnership with the Province of Nova Scotia to develop and promote our creative industries for the benefit of all Nova Scotians.

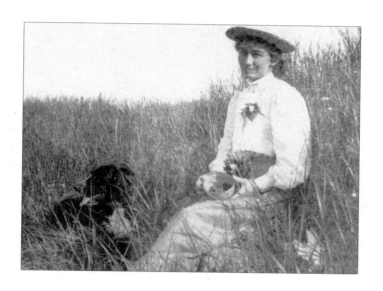

This book is dedicated to Sarah Beatrice (Trixie) Bouteillier.
Thank you for lighting my path.

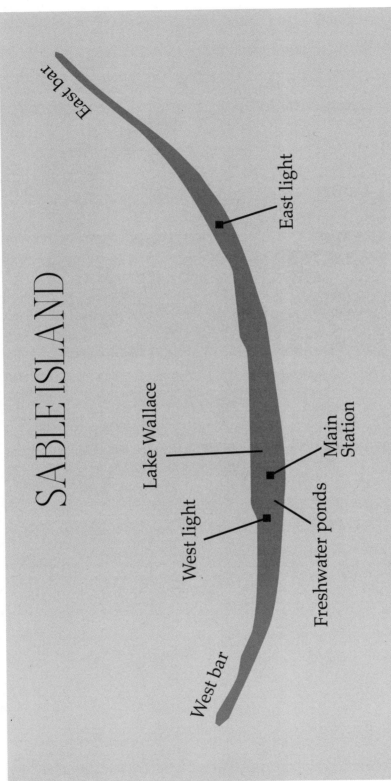

SABLE ISLAND

East bar

East light

Lake Wallace

West light

Main Station

Freshwater ponds

West bar

CONTENTS

꒰ *Portrait of Robert Jarvis (R. J.) Bouteillier, superintendent of Sable Island, in 1917.*

PREFACE

I n the late nineteenth and early twentieth centuries, photography was a fledgling art form. Tintypes and daguerreotypes of the 1860s had given way to glass plates and film spools in the 1900s. A growing number of men and women captured images of the world around them.

The process of photography works on the premise of a surface—glass, paper, or cellulose, which has been coated with a light sensitive product—being exposed to a direct stream of light. Early photographs were circular because of the round opening through which the light entered the camera.

When Dr. J. Dwight came to Sable Island in 1894 looking for nests of the Ipswich sparrow, fourteen-year-old Trixie was amazed at his camera. Like so many elementary students today who play with pinhole cameras to learn how photographs are made and how the pinprick of light leaves an image on the

❧ *A gang of wild ponies on a path through the dunes, 1900.*

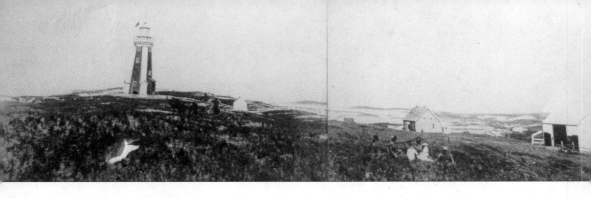

⅋ *A panoramic shot of the east lighthouse taken by Trixie, 1901.*

back of the closed box, she built her own camera obscura. She understood why the image was upside down and she knew that, when developed, objects in the image that were actually black would appear white and vice versa. Everything else would be some gradient of gray.

Dr. J. Dwight captured his images on glass plates coated with a silver salt solution. The chemicals were challenging to work with, but young Trixie was not deterred. She begged her father to build a small darkroom for her off the big kitchen. It didn't need to be large, just enough room for a small table, a shelf for her chemicals, and a rope line to hang the photographs from.

⅋ *Trixie's nineteenth-century selfie captured on a glass plate, 1899.*

In 1889, George Eastman, an entrepreneur from Rochester, New York, invented the product we now call film. It was flexible, strong, and could be wound around a spool. When it was painted with a dry gelatin, the film absorbed light very quickly. Developing the picture now took only seven or eight minutes, instead of thirty or more as in the days before film. His invention made the mass-produced box camera affordable for the everyday person.

Trixie received her Brownie C 2 camera from Dr. Alexander Graham Bell in 1901. The Brownie No. 2 was the first to use 120 film. Made of nubbled leatherette over heavy card paper, the Brownie took excellent pictures. It measured 6 x 7 x 4 inches and had two viewfinders—one for portrait and another for landscape shots—and a very dependable shutter. On the top were two sliding

🖎 *Trixie with her Brownie camera coming into Halifax Harbour, 1901.*

mechanisms: one for a bulb or time setting and the other a choice of three apertures. The back of the camera opened to place the spool of film in and through a small, red plastic disc on the back of the camera, the exposure number was visible.

With her Brownie, Trixie snapped and developed many of the photos in this book. She mounted her favourites on pressboard and always wrote a caption on the reverse. Modern researchers and historians are most grateful for these

🖎 *Moonlight time exposure of the view from the Main Station looking southwest, 1906.*

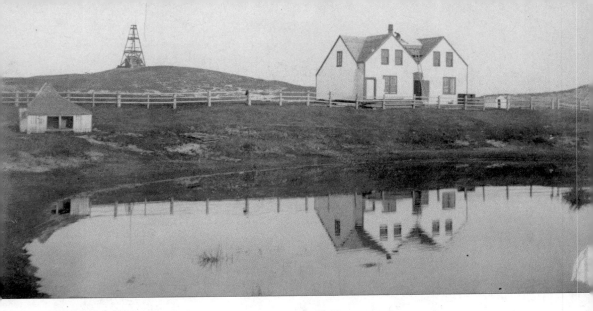

Reflection of station #3 at the east end of Lake Wallace, 1906.

treasures as they help with corroboration of facts, dates, and stories. She experimented with many photographic techniques we recognize today: time exposure, tinting, portraits, landscapes, and still life. The camera gave her new eyes to see the world around her.

Trixie's brother, Dick, took the photo on the cover of this book. Trixie is the figure on the right and J. D. Taylor, a wireless engineer, is the man on the left. Trixie's Labrador retreiver, Cholo, accompanies the riders down the beach. The hulking wreck of the *Skidby* rests on the sand in the background.

In 1984 my family donated many of Trixie's original pictures to the Nova Scotia Archives for safekeeping and the perpetual enjoyment of future generations, but hundreds of others rest in photo albums in my home. Whenever I wish, I can travel to Sable Island and walk the dunes with my ancestors. I am tremendously proud of their tenacity and intuitive wisdom in preserving their lives at the Main Station so many years ago.

INTRODUCTION

The year is 1910. Sarah Beatrice Bouteillier, or Trixie to everyone who knows and loves her, is approaching her thirtieth birthday. On a sun-drenched April morning, she reluctantly pulls away from her father's strong embrace. The goodbye she has imagined for the past several weeks is one hundred times worse in reality. This is it: her last day on her beloved island. The lead weight of grief deadens her arm as she raises it in a final wave to her parents. Rooted to the sand, two plumb lines of despair, they gaze to the horizon, their faces expectant with loss. Courageously, she turns to face the sea. Trixie is the last of six children to climb into the surfboat and dash to the *Lady Laurier* waiting a kilometre offshore.

The boatman gives the signal. Four sailors hold tight to the gunwales as they run alongside the boat and guide it, bow first, into the water. At the last moment, they jump aboard and raise the oars. In one fluid motion, four oars slice the waves. Stroke by stroke, they propel the boat seaward to the waiting supply ship. Crest after crest, the tall pointed prow rams into the thundering rollers, which break over shoals stretching far to the northwest. For twenty-five years she has called Sable Island home.

Sable Island in Black and White is a pictorial record of life on the island between 1880 and 1910. The book chronicles the life of Trixie's father, Robert Jarvis (R. J.) Bouteillier, who began his career on Sable Island as its carpentry foreman in 1879, and was appointed superintendent in December 1884. Six months later his wife, then seven months pregnant, and five children, aged three to nine, joined him.

In both story and photographs, this book reveals what life was like for the inhabitants on Sable Island more than one hundred years ago: the lightkeepers, the boatmen at the main sailors' house or in the distant lifesaving stations around the island, and the families under the leadership of Superintendent R. J. Bouteillier at the Main Station.

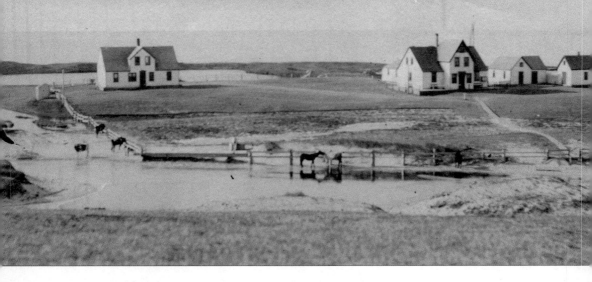

L–R: Sailors' home, Main Station, forge, and storage building, 1901.

On Sable Island 130 years ago, travel was on horseback or by horse cart, communication was by letter, and food on the table depended on the success of a large garden, bounty from the sea, domestic livestock, and regular supply ships from the mainland.

This book documents a time in Nova Scotia's history that is all but forgotten. Most of the photos herein were taken and developed by Trixie, some by Superintendent Bouteillier, and others by the Department of Marine and Fisheries or the Department of Transportation on their regular inspection tours of Sable Island. A few were even taken by famous guests such as Dr. J. Dwight in 1894 and Dr. Alexander Graham Bell in 1898.

Travel back in time to 1880, when a stalwart group of ordinary people called Sable Island home. Clawing out an existence on a spit of sand 160 kilometres from the North American mainland, these men and women bequeathed a legacy of determination and courage to future generations. Although it was known over the centuries by a host of different names including Santa Cruz, Isle Fagundez, Isola del Arena, Île de Sable, Sable Island, and most recently in 2013, Sable Island National Park Reserve, it was the infamous nickname—the Graveyard of the Atlantic—that was respected and feared in any language.

In the late nineteenth century, there were four lifesaving stations on Sable, all fitted with signal towers for communication by flag in good weather. The Main Station was located on the westerly end of the island; station #2 on the north side, mid-island; station #3 on the south side, mid-island; and station #4 on the eastern side of the island. Built in 1873, two lighthouses rose almost thirty metres at either end of the sand crescent, brave warning beacons for passing ships.

⇥ The Skidby *broken amidships off the shore of Sable Island, 1909.*

Of course the primary purpose of the forty or so residents on the island was lifesaving, but there were countless other duties that filled their days. If they wanted fresh produce, they had to grow it. Families at each of the four lifesaving stations planted large gardens. Beets, mangels, carrots, turnips, and potatoes flourished. At the Main Station and lighthouses, men tended to many four-legged creatures including pigs, oxen, and cattle. Chickens and ducks ran free at all

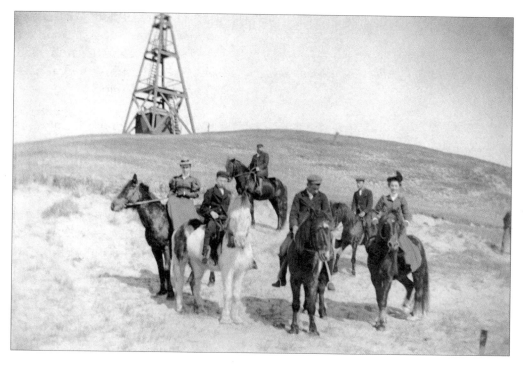

⇥ *The Bouteillier family out riding near the Main Station in 1898. L–R: Bertha, Jim, Dick, Clarence, and Trixie; R. J. behind.*

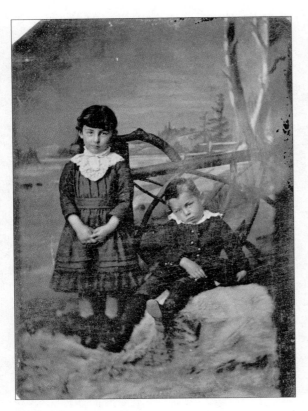

four stations, a good source of fresh eggs and meat. The smokehouse at the Main Station dried hundreds of cod and haddock, providing a welcome change in dining fare. Every now and then, a lobster crate full of the succulent crustacean washed overboard from a passing fishing schooner, and offered up a rare feast.

Lying in the path of both the Labrador and Gulf Stream currents, Sable Island has morphed and changed from year to year, keeping carpenters busy repairing buildings battered by wild winds and salt spray, or clobbered by the ferocious tides and storms which eroded the very foundations of homes and boathouses before sucking them out to sea. Between 1873 and 1888, the west lighthouse was dismantled and relocated twice—first one, then two kilometres eastward—on the heels of rapacious waves, winds, and tides which licked at the base of its very foundation.

Blueberries and cranberries sketched a canvas of blues and reds in the protected valleys of the Barrens. Harvesting barrel after barrel of these berries filled early summer and late fall days.

An endearing part of the natural landscape, the brazen and spirited wild ponies roamed freely in gangs with sophisticated names like Ottawa or York. Even during especially harsh winters when hay was provided for them, they preferred to face the brunt of the cold and forage in the wild.

Each season packaged and delivered a unique set of challenges for the island inhabitants. It was not an easy life, nor was it a life for everyone, but there was no denying it was a memorable life.

🖎 *A view from the Main Station to the west light. Taken in 1886 and tinted by Trixie in 1908.*

In her memoirs, Trixie shares her thoughts about her Sable Island home:

> *They said it was a terrible place, that people couldn't be ordinary human beings if they wanted to live in such an isolated, bleak place. Officials and visitors would brave the crossing on the steamer and spend a few hours or a day and go back to the mainland thinking they knew all about Sable Island and the savages who lived there. That wasn't true at all. It was beautiful and unique, oh so unique. Sure there were terrible shipwrecks and months of fog, but it was home and I couldn't imagine growing up anywhere else....*

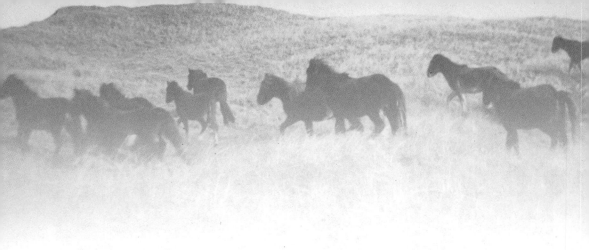

SETTLING THE ISLAND

S hrouded in fog launched by sea spray and foam, cursed by massive tides and surf, Sable Island's rapacious appetite for shipwrecks was notorious among mariners for centuries. Following a spate of shipwrecks in the latter part of the eighteenth century, Sable Island quickly became a priority issue in the Nova Scotia Assembly. Lieutenant Governor John Wentworth was determined to build a lifesaving station on the notorious sandbar, and in June 1801, he allocated £600 (about $20,000 in modern currency) for the enterprise.

Since the 1500s there had been a continuous, albeit sporadic, human presence on the crescent of sand lying three hundred kilometres from anywhere in the cruel, indifferent North Atlantic Ocean. In October 1801, a man was finally appointed to live on the island full time: he was put

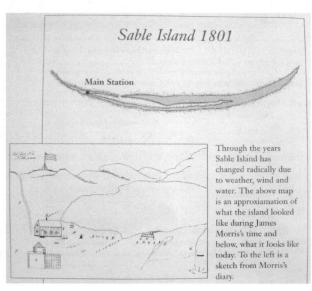

Sable Island 1801

Main Station

Through the years Sable Island has changed radically due to weather, wind and water. The above map is an approxiamation of what the island looked like during James Morris's time and below, what it looks like today. To the left is a sketch from Morris's diary.

🖎 *James Morris's sketch of Sable Island showing the flagstaff and first permanent settlement of the island, drawn in 1801.*

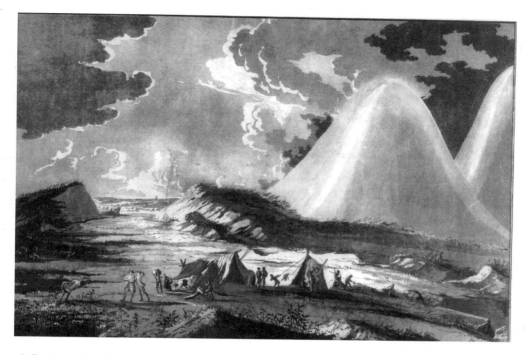

⮌ *Cartographer Frederick Des Barres's 1766 aquatint of the survey camp at Naked Sand Hills on the southeast shore of Sable Island.*

in charge of the new lifesaving station. James Morris became Sable Island's first superintendent and he and his wife, their son, and three appointed lifesavers wet their feet in the surf on October 17, 1801.

Morris's Sable Island journals were reprinted in 2001 to mark the two hundredth anniversary of his arrival, and they document those difficult years in vivid detail and wonderful hand-drawn sketches. Between the summers of 1766 and 1768, Colonel Frederick Wallet Des Barres, a cartographer, completed the first land survey of Sable Island. His aquatint of the Naked Sand Hills showing the surveyors' work camp on the island's rugged southeast side was used as the frontispiece for the reprinted journals in 2001.

Before the storms of December flared upon the island, Morris's first priority was to erect shelters and signal towers. The superintendent's prefabricated home—each plank pre-cut and numbered for simple construction—was built on the west end of the island near the Old Harbour. The second home, Halfway House, was built near the middle of the island at the end of Long Pond (later renamed Lake Wallace in honour of Michael Wallace, one of Nova Scotia's administrators of the Humane Establishment).

Superintendent James Morris hoisted a flag at the top of each tower, and left a small telescope, called a spyglass, in a chest on each platform to use in search of

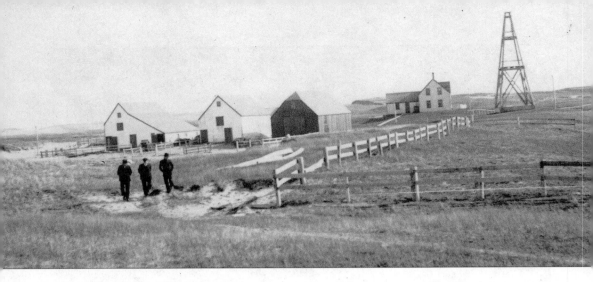

The signal tower at station #3, at the eastern edge of Lake Wallace, 1901.

ships in distress. It was rudimentary, but it was all they had. At the main house, Morris mounted a cannon atop a wooden platform to warn ships that broached too close to the shallow sand to steer clear.

Eighty years later, Superintendent R. J. Bouteillier fired the same cannon on special occasions. His children, young Trixie and her brothers, learned to send flag messages and use spyglasses to comb the surface of the sea for any sign of a wreck or a vessel in trouble. If they saw something, they signalled the other towers, responded to, or passed on distress signals sent from ships.

The lower boathouse at Main Station and the signal cannon on its block, 1893.

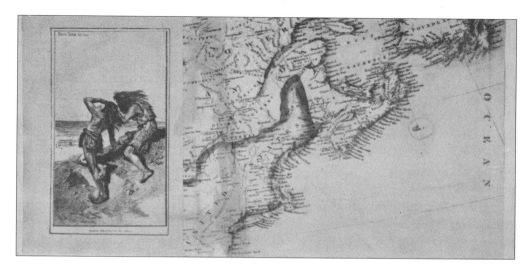

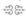 An illustration of la Roche's convicts sighting their rescue ship in 1603 and a map with Sable Island circled, indicating where la Roche landed in 1598.

Eel Pond Gulch, Haul Over, Halfway Hills, Monkey Puzzle Hill, Trott's Cove, York Barrens—these strange place names dot the many maps of Sable Island drawn over the centuries. Some names remained in use for decades, while others drowned in the rivulets of the past. The natural properties of landmarks (such as hills) often provided their own names—Volcano or Naked Sand Hills. Sometimes, place names were christened by events or the resting place of ships, like *Eliza* or *Crofton Hall*. Others places were named by those who attempted to colonize the windswept tentacle of sand.

Although the concept of a penal colony is appalling today, in the sixteenth and seventeenth centuries it was common practice to settle new lands with contingents of male and female convicts. Sable Island was one such prospective colony.

In March 1598, the Marquis de la Roche, ten officers, and fifty convicts landed on Sable Island, which he promptly renamed Île de Bourbon in honour of his home in Brittany, France. After loading tools and food for the settlers and officers, the Marquis, viceroy of New France, continued on to Acadia in search of a permanent location for his new colony.

He had no intention of abandoning his new island settlement, though, which he hoped would earn him fame and riches through the fisheries and the fur trades. But that December, on his way back to Sable Island, a terrible storm blew him past the island and on to France. For several years the Marquis de la Roche sent supply ships to the island with wine and clothing, but in 1602,

having fallen out of favour with the court, he was imprisoned. The supply boat did not sail.

That winter, a desperately cold one, the convicts on Sable Island revolted: they turned on each other, killing their leaders and butchering dozens of their compatriots. Reduced to a mere twelve souls, the settlers struggled on. In the spectre of the dead, the vegetables in the French Gardens and the wild cattle, fish, seals, and walrus helped the remaining colonists survive. They sought shelter from the vicious snow squalls in burrowed-out sand caves. Come spring, when a ship did finally arrive, the remaining men were clad in animal skins, filthy and desperate.

The sea keeps its cards very close to its chest. Every time a fisherman left for the Grand Banks, he never knew if the indifferent North Atlantic would write his name in brine. On an October afternoon in 1903, the sky darkened and the winds screamed. A nor'easter screeched down the alley from the north, and one unfortunate schooner was caught in the fatal bend of Sable Island. Vicious, wind-harried surf whipped over the gray decks and icy salt spray stung the sailors' eyes, as the craft was lured inexorably towards the killing sand bar. The *Topaze*, from Saint Pierre and Miquelon foundered in the crush of the maelstrom. Eight sailors drowned and were buried in the Monkey Puzzle Cemetery. No one has yet been able to crack the puzzle behind this hill's name, but sailors approaching Sable Island knew it and feared it.

Towards the east end of the island is a place still known as Whalepost. In the 1850s, five sperm whales were stranded there. Perhaps they had greedily raced after a school of herring, or perhaps a violent storm blew them off course. Whatever the cause, they were beached and died. For months, gulls and terns feasted on the leviathans until nothing but bones remained. In time, all remnants of the majestic mammals disappeared, but the name remained.

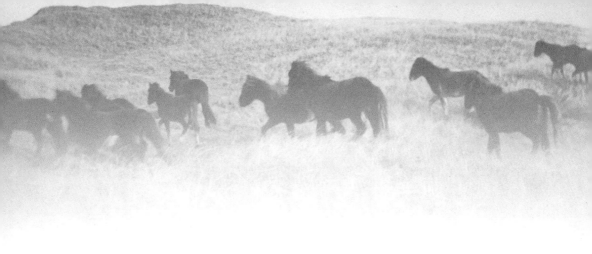

DOROTHEA L. DIX

Were it not for the menace Sable Island presented to navigation and the consequential necessity of maintaining life stations there, it is likely humans would never have inhabited the island.

Despite establishing lifesaving stations in 1801, shipwrecks continued frequently and with great loss of life. Recorded in subsequent superintendents' logs, the losses—of both human life and cargo profits—continued to outpace the efforts of the men charged with saving lives.

In the summer of 1853 Dorothea Dix—devout Christian, famed philanthropist, and social activist—visited Sable Island. She had come to Halifax from Boston not only to enjoy the brisk sea air, but also to consult with Dr. Hugh Bell, a former mayor of Halifax and member of the legislature. An advocate for the less fortunate, Dr. Bell pledged to alleviate the inhumane treatment of the mentally ill. In his position as chairman of the Board of Works, he had petitioned the government for the construction of a hospital to replace the poor houses and jails where patients were treated "like inferior animals to be caged and chained and whipped into submission."

Dorothea Dix was summoned to assist Dr. Bell in determining the feasibility of a joint mental institution for the three Maritime provinces to be built near Dartmouth, a site Dix had selected. The proposed new hospital for the mentally ill supported the notion that mental illness was caused by environmental stresses and should be treated by individual therapy in a pleasing physical setting. Fortuitously, Dr. Hugh Bell was also responsible for the administration of Sable Island. Miss Dix had heard rumours that the island was a place where local

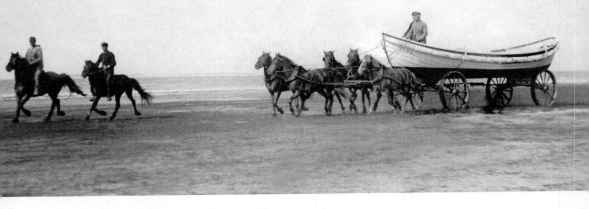

⧉ *Lifeboat* Reliance *being pulled across the beach by a five-horsepower team, 1894.*

families sent their unstable relatives, abandoned and left to their own resources. Miss Dix could not sanction such treatment of the mentally ill. She convinced Dr. Bell to take her there.

Dix remained on Sable Island for several days exploring and enjoying the warm breezes, but her mind was also at work. She noted in her diaries that the British government had not erected lighthouses, nor provided fog bells or rescue boats. The superintendent at the time, Matthew McKenna, was forced to make do with what he had. This did not sit well with Miss Dix. Fortunately—or unfortunately, as the case may be—while she was on the island, the schooner *Guide* struck the sandbar on the south side. The combination of dense fog and the schooner's full sails spelled complete disaster. As a witness to the rescue operation, Miss Dix was appalled at the conditions and the poor lifesaving equipment the boatmen had to use.

In a heavy sea, the *Guide's* crew was rescued in the island surfboat, but their captain refused to leave his stricken ship. He ranted and raved as he paced the deck in the throes of manic stress. Dorothea Dix recognized the signs of his demented state and insisted that the crew row her out to talk with the captain. She convinced the men to bind him hand and foot and get him into the surfboat. She talked calmly to him and managed to ease his fears. The captain was finally brought to safety and Miss Dix had a new mission.

Cut from the same determined bolt of cloth as social reformer Elizabeth Fry, her London, England, counterpart, Dorothea Dix, immediately upon her return to Boston, began a campaign to acquire lifesaving equipment for the isolated outpost of Sable Island.

No one dared argue with a woman who championed God as the dealmaker. Within weeks, she had promises of four donated boats, a life car, a rocket with ammunition to shoot a line to stricken ships, and coils of manila rope. She named the boats the *Reliance*, the *Grace Darling* (after the daughter of a famous

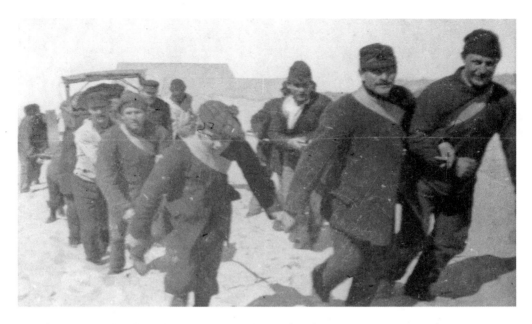

Lifesaving staff pulling the two-thousand-pound rocket apparatus to a wreck, 1897.

lightkeeper in the Farne Islands), the *Samaritan,* and *the Queen Victoria of Boston.* In addition to the gear, she donated five hundred books for the entertainment of any shipwrecked men and women who might be held captive by circumstance.

Unfortunately, the brig transporting the lifesaving cargo was driven ashore on Cranberry Head near Yarmouth, Nova Scotia, in late 1853. But Miss Dix was not to be discouraged. The brig's crew made repairs and replacements, and the equipment was finally delivered to Sable Island and Superintendent McKenna on November 25, 1854. Ironically, just one day after the lifesaving equipment arrived, a ship called *Arcadia* carrying cargo, 21 crewmembers, and 149 German passengers, was driven ashore on the little island in a wicked late-November storm.

At first light on November 27, east lighthouse keeper James Farquhar spotted the ship. It had struck the bar sometime during the night. He rode at full speed to the Main Station where he alerted Superintendent McKenna, leaving his son, twelve-year-old Jim, to man the light until he returned.

By 9:00 A.M., five strong horses were hitched to Miss Dix's new life cart, where *Reliance* had been loaded. They set off from the Main Station for the wreck, eighteen nautical miles away. *Arcadia* laid with its keel to the shore, its sails and masts to the open sea. Exhausted as they were, the lifesavers steered their stout rescue crafts to the wreck. All through the daylight hours, the large lifeboat, *Reliance,* and the smaller surfboats *Samaritan* and *Queen Victoria* made countless trips back and forth to the wreck, but it was November and darkness came early.

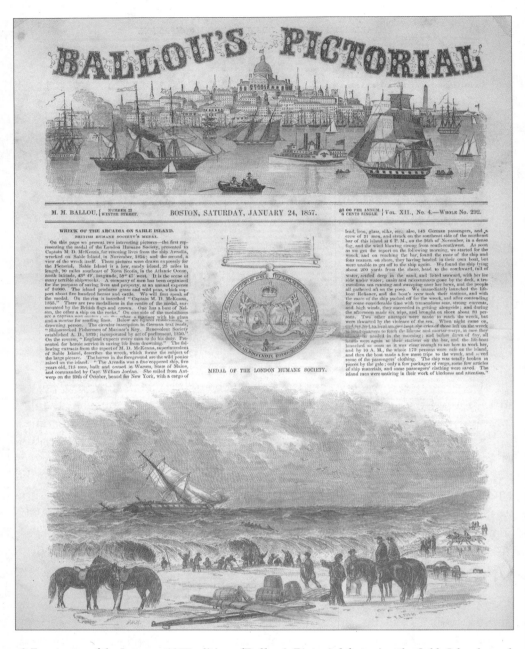

M. M. BALLOU, { NUMBER 22 WINTER STREET. } BOSTON, SATURDAY, JANUARY 24, 1857. { $3 00 PER ANNUM. 6 CENTS SINGLE. } VOL. XII., No. 4.—WHOLE No. 292.

WRECK OF THE ARCADIA ON SABLE ISLAND.

BRITISH HUMANE SOCIETY'S MEDAL.

On this page we present two interesting pictures—the first representing the medal of the London Humane Society, presented to Captain M. D. McKenna, for rescuing lives from the ship Arcadia, wrecked on Sable Island, in November, 1854; and the second, a view of the wreck itself. These pictures were drawn expressly for the Pictorial. Sable Island is a low, sandy island, 25 miles in length, 90 miles southeast of Nova Scotia, in the Atlantic Ocean, north latitude, 43° 49', longitude, 59° 47' west. It is the scene of many terrible shipwrecks. A company of men has been organized for the purpose of saving lives and property, at an annual expense of $4000. The island produces grass and wild peas, which support about five hundred horses and cattle. We will first speak of the medal. On the rim is inscribed "Captain M. D. McKenna, 1855." There are two medallions in the centre of the medal, surmounted by the British flags and crown. One has a bust of Nelson, the other a ship on the rocks. On one side of the medallions are a captain and sailor; on the other a mariner with his glass and a mortar for sending lines. Below are figures resuscitating a drowning person. The circular inscription in German text reads, "Shipwrecked Fishermen of Mariner's Key. Benevolent Society established A. D., 1839; incorporated by act of parliament, 1850." On the reverse, "England expects every man to do his duty." Presented for heroic service in saving life from drowning." The following extracts from the report of M. D. McKenna, superintendent of Sable Island, describes the wreck, which forms the subject of the large picture. The horses in the foreground are the wild ponies raised on the island. "The Arcadia was a fine coppered ship, five years old, 715 tons, built and owned in Warren, State of Maine, and commanded by Capt. William Jordan. She sailed from Antwerp on the 29th of October, bound for New York, with a cargo of

lead, iron, glass, silks, etc.; also, 149 German passengers, and a crew of 21 men, and struck on the southwest side of the northeast bar of this island at 6 P. M., on the 26th of November, in a dense fog, and the wind blowing strong from south-southwest. As soon as we got the report on the following morning, we started for the wreck, and on reaching the bar, found the mate of the ship and four seamen on shore, they having landed in their own boat, but were unable to get off to the ship again. We found the ship lying about 200 yards from the shore, head to the southward, full of water, settled deep in the sand, and listed seaward, with her lee side under water; main and mizzenmasts gone by the deck, a tremendous sea running and sweeping over her decks, and the people all gathered aft on the poop. We immediately launched the lifeboat Reliance, and the boat's crew took their stations, and with the mate of the ship pushed off for the wreck, and after contending for some considerable time with tremendous seas, strong currents, and high winds, they succeeded in getting alongside; and during the afternoon made six trips, and brought on shore about 90 persons. Two other attempts were made to reach the wreck, but were thwarted by the violence of the sea. When night came on, and we had to haul up our boat, the cries of those left on the wreck for aid quarters to fetch the life-car and mortar-warps, in case they should be needed in the morning; and before dawn of day, all hands were again at their stations on the bar, and the life-boat launched as soon as it was clear enough to see how to work her, and by 10 A. M., the whole 170 persons were safe on the island, and then the boat made a few more trips to the wreck, and saved some of the passengers' clothing. The ship was totally broken in pieces by the gale; only a few packages of cargo, some few articles of ship materials, and some passengers' clothing were saved. The island men were untiring in their work of kindness and attention."

MEDAL OF THE LONDON HUMANE SOCIETY.

⫷ *Front page of the January 1857 edition of* Ballou's Pictorial *featuring the Sable Island wreck of the* Arcadia.

Nightfall put an end to the boatmen's trips to the wreck, leaving dozens of survivors aboard. All night their terrorized cries screeched across the waves, but there was nothing to do but wait for the sunrise.

The next morning, lifesavers made their way out to *Arcadia* again and again, bringing in twenty survivors at a time. The hardy lifeboat *Reliance* had to be hauled up to the windward side of the *Arcadia* by a team of wreck horses who strained in their harnesses to counteract the set down of the sea and the claws of the current. The men did not give up.

For forty-eight hours of the storm's brutal punishment, Captain William Jordan remained aboard the *Arcadia,* knocked down by the heavy sea and injured. He was the last to leave on *Reliance*'s final trip. Within hours, his ship broke amidships and was carried out to sea. All 170 crewmembers were saved. It was a truly heroic effort but if the ship had foundered two days earlier, before Miss Dix's lifesaving equipment had arrived, it is likely that all would have drowned.

In the summer of 1854 several months before the wreck of the *Arcadia*, Dr. John Bernard Gilpin, one of only five doctors in Nova Scotia qualified as both physician and surgeon, arrived on Sable Island to deliver Superintendent McKenna's third child. Intrigued by the natural beauty of the island, he spent many happy hours sketching the horses, seals, dunes, and deteriorating shipwrecks. He spoke with the boatmen, lightkeepers, and others involved in the frequent rescues, and developed a great respect for the many dangers of their important work.

Several years later, in celebration of the successful rescue of all souls aboard the *Arcadia*, Dr. Gilpin recalled their detailed descriptions as he created his sketch of the doomed ship in its death throes. Along with the rescuers and lifeboats, he included young Jim Farquhar, his dog, and his horse, Bobs.

Dr. Gilpin's engraving of the stricken *Arcadia* was published in the January 27, 1857, edition of *Ballou's Pictorial*, a popular drawing-room book published in Boston, Massachusetts. Since he was well aware of Dorothea Dix's instrumental role in procuring lifesaving equipment for Sable Island, Gilpin believed the men who had donated funds in Miss Dix's campaign would be interested to read about Superintendent McKenna's leadership and the excellent performance of the lifeboats.

Dr. Gilpin sent a copy of the popular magazine to the Farquhars. When young Jim Farquhar left Sable Island in 1861 to join the crew of a Yankee ship during the Civil War, he left Gilpin's sketch—which he had mounted on tack board—hanging in his parents' home at the east lighthouse. Years later, when young Jim became a captain on the Sable Island run, he gave the picture to Trixie's youngest brother, Jim. The thick, leather-bound journal containing Dr. Gilpin's sketch is now in my care, and is one of my most precious belongings.

THE SS STATE OF VIRGINIA AND THE A. S. H.

Trixie's father, Robert Jarvis (R. J.) Bouteillier, was a strong, calm man who filled any room he entered. He was the seventh superintendent of Sable Island, serving on the ribbon of sand from 1884 to 1913. In July 1879, when he was still the foreman of carpentry, he helped the lifeboat crew when the SS *State of Virginia*, a British passenger ship, struck ground on the south side of the island, almost five kilometres west of the Main Station, in a mid-summer storm.

Growing up in French Village on St. Margarets Bay, R. J. had lots of experience with boats. He stood 6'3" and was very strong. As the crew was short a boatman, they recruited the young carpenter to take up an oar. They rowed for hours to reach the stricken ship. The *Grace Darling* brought one load of passengers safely ashore, but the second load upset and nine passengers drowned. R. J. had witnessed the sea at its most unforgiving.

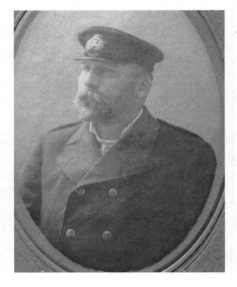

R. J. in uniform on his tenth anniversary as superintendent, 1894.

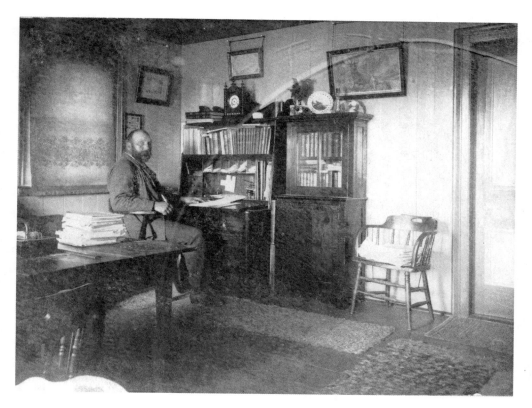

༄ *R. J. at his desk in the Main Station, 1894.*

For almost thirty years, Bouteillier acted on behalf of the Government of Nova Scotia as Sable Island's doctor, lawmaker, dispenser of stores, minister, and, most importantly, head of lifesaving. As the years passed, he annotated his copy of S. D. McDonald's 1890 Sable Island shipwreck map to include every ship that foundered during his years as superintendent. The map is now blackened from the fine nib of his pen. During his tenure, he added the names of more than twenty-five ships that became ensnared in the clutches of the sand or hoodwinked by the dense blankets of fog that enveloped the island for more than 120 days of any given year.

R. J.'s stewardship of the island bookended the twentieth century: for two decades before the turn of the century and twelve years after, he provided stability and consistent leadership to Nova Scotia's most isolated outpost.

When R. J. had first arrived in 1879, there was neither telephone nor telegraph on Sable Island. By the time he retired in 1913, a telephone line linked the lifesaving stations and the lighthouses, and a wireless telegraph linked the island with mainland Nova Scotia and the rest of the world.

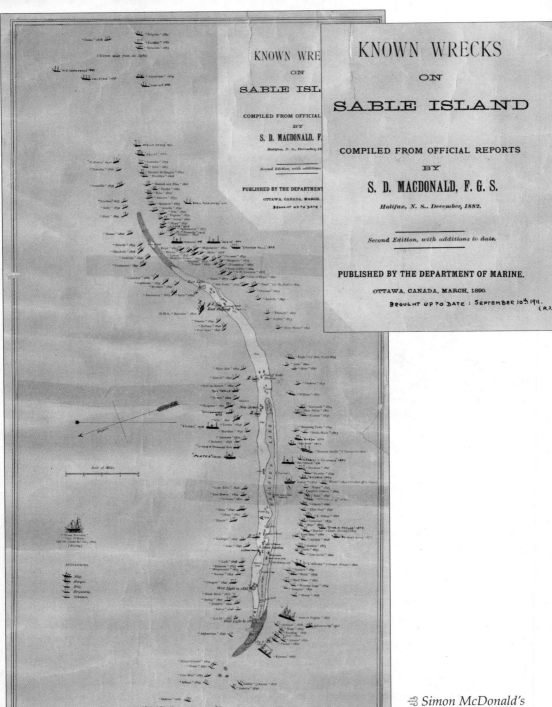

Simon McDonald's 1890 shipwreck map, annotated by R. J. in 1911.

In 1884, R. J. recorded his first official shipwreck as superintendent—the two-masted brigantine *A. S. H.*—with three dead and one saved. The brig had left Saint-Malo, France, and after a stop in Saint Pierre and Miquelon for a load of fish, was en route to Boston. If telephones had been on the island when the *A. S. H.* wrecked, it is very likely no one would have died. Instead, William Merson, the west lightkeeper, had to ride eight kilometres in a blinding snowstorm to the Main Station to get help to search for the lost crewmen.

In a letter to the Department of Marine and Fisheries, R. J. wrote:

> *Much praise is due William Merson, keeper of the West End Light, for the prompt manner in which, at the risk of his own life, set out alone and brought word to me as soon as possible as I could not afterward with my men, without the greatest difficulty and risk, find the wreck. I could also mention the prompt action and willing obedience of the men at the Main Station.*

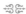

Following the tragedy of the *A. S. H.*, R. J. demanded telephones be installed on the island at the lights and the lifesaving stations, removing the necessity of the boatmen having to carry the tidings of a wreck to the Main Station, thus delaying the lifeboat's departure. Poles and wire arrived on the next supply ship. R. J. examined a route for the line and considered the work to be quite practicable. By September 1885, poles were in place and telephone wire strung. The Sable Island T&T was founded.

Hauling telephone poles to connect the stations and lighthouses, 1885.

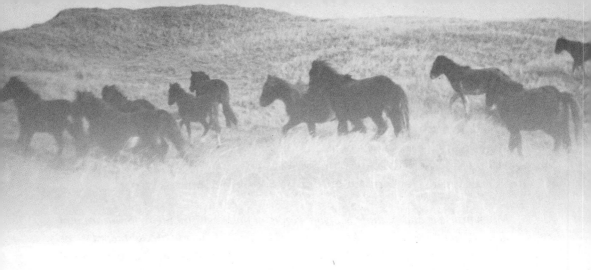

LIFESAVING

Of the forty-six names on the 1901 census for Sable Island, only fifteen were listed as boatmen, lightkeepers, or station keepers. When a ship foundered, though, everyone on the island helped: the women prepared meals, the children brought dry socks and shirts, and, under R. J.'s leadership, the men rowed until exhaustion overtook them…and then they rowed some more. R. J.'s crew never underestimated their duty to their fellow man: boatmen yes, lifesavers all.

Shipwrecks littered the beaches. One day the ribs of a past wreck locked in its watery grave would be visible, but following a storm all remnants of the tragedy would be snatched from the sand's clutches. On other occasions, churning surf would carve out sections of the beach and expose anchors from shipwrecks that had been buried decades before.

It was not uncommon to discover bodies on the beach after heavy storms, the grim details of which R. J. regularly penned in his logs:

> On the north beach, two legs in ragged blue sailor's pants attached to a battered torso. At the tip of the east bar, discovered with no arms, a bruised and bloodied skull stared up at would-be rescuers. On the south beach, marionetted by the surf in a macabre dance, a body rose up almost to a sitting position. Rigging from the ship acted as strings for its cruel puppeteer, and entangled the dismal figure.

Sometimes the bodies were from ships lost kilometres from Sable Island, other times they were from known wrecks. R. J. always tried to identify the

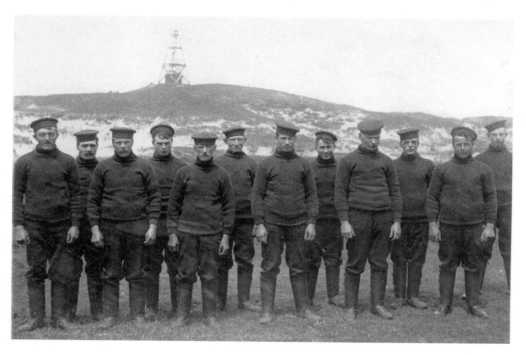

🐚 *Lifesaving crew (unidentified) in their uniforms, 1898.*

remains in order to notify their next of kin. Despite his best efforts, though, the cemetery on Monkey Puzzle Hill near the Main Station had its share of unmarked graves.

The majority of residents lived at the two lighthouses and the Main Station, while a smaller number lived at the mid-island rescue stations. The Main Station, also known as station #1, housed the superintendent's family and staff: Mr. Egan, the carpenter; Mr. Cleary, the cook; and five or six sailors to man the lifeboat *Reliance*.

The west lightkeeper and his family lived about six kilometres from the Main Station. Their lighthouse was a white octagonal wood structure that rose almost thirty metres above a concrete base. Atop the tower was the lantern with a revolving light that flashed every twenty seconds. The east lightkeeper's family lived at the east end of the island overlooking the beach and the treacherous northeast sandbar. That lighthouse was painted in eight alternating red and white panels and stood more than twenty-seven metres tall. Erected in 1873 at a combined cost of $40,000, the lights—visible from twenty-four nautical miles out at sea—warned ships crossing the North Atlantic that they were near Sable Island, which made their passage much safer.

Lifesaving crews lived at stations #3 and 4, and rescue boats waited in boat-houses near the beach. Every day, men from these rescue stations patrolled the

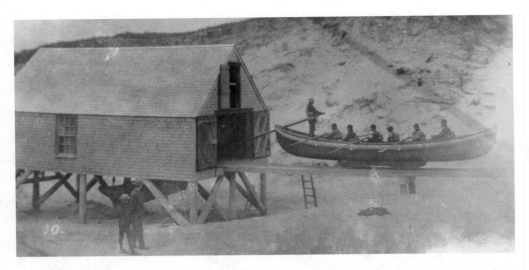

☙ *The lifesaving crew performing dryland training drills, likely on the* Grace Darling, *at the Main Station boathouse, 1889.*

coastline on the lookout for ships in trouble. On clear days, they needed only climb to the top of the signal towers, scan the kilometres of dangerous shoals with their spyglasses, and communicate between towers using flag signals.

But it was in foggy weather that the men had to conduct their patrols of the island on high alert. With an altitude of only thirty metres, less in some places, the island was very difficult to see from offshore; in the dead of night, with a

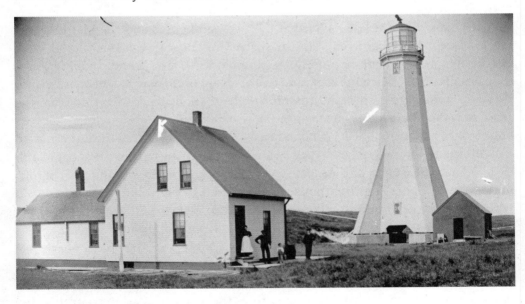

☙ *The west lighthouse and keeper's dwelling, c. 1890.*

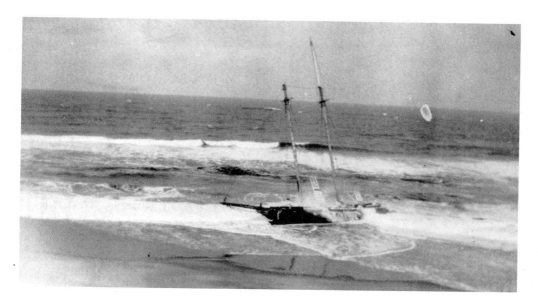

⚓ *The schooner* Chas. H. Taylor, *adrift off Sable Island, 1897.*

full surf and dense fog, the danger of shipwrecks increased dramatically. When those circumstances joined forces, even the most experienced mariner could be lured into the sand's deadly grip.

Blinded by the fog and the raving winds, the lifesaving staff devised an ingenious way to patrol the island. At precisely the same time, their pony patrols would leave each lighthouse or station and walk along the beaches in search of wreckage. Each piece of driftwood was examined to determine if it had come ashore from a wreck. It was lonely work. They counted the predetermined number of their horses' steps, met their partners, exchanged news or reports, and turned back. In this manner the men, affectionately known as "roundsmen," patrolled the complete perimeter on both the north and south sides of the island.

When heavy surf prevented a lifeboat from reaching a wreck, the crew used a rocket apparatus: lifesavers shot a whip line from a Lyle gun on the beach to the stricken ship. Once secured onboard, they sent a stronger hawser cable, strung through a block and tackle, back to shore. The land crew then attached a breeches buoy to the heavy line and, like using a clothesline, a crewmember reeled the buoy onboard. Stranded sailors would then sit in the circular ring with their feet suspended over the ocean, and the buoy ran back to shore along the whip line. The frightened survivor dangled high above the treacherous surf as he was reeled in from the ship to the safety of land. Survival instincts generally outweighed fear because, after all, in order to survive a shipwreck in the Graveyard of the Atlantic, one could not afford to be squeamish.

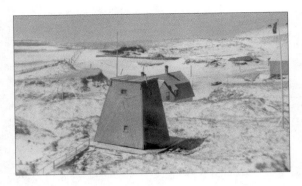

🕮 *A view of the north beach, taken as seen from the gallery of the lighthouse tower.*

R. J. also had to protect stranded ships from looters once the crew was safely on land. His staff was on watch for fishermen who, under cover of night, often tried to steal all manner of supplies from a stricken ship: rigging, stores, navigation equipment, clothing, or anything of value. R. J. posted paper notices on ships forbidding entrance to anyone.

In October 1902, R. J. found an abandoned schooner just off the north beach. Its condition led him to believe that scavengers had already done their worst. The entry in his log details the damage: "Derelict looks as if it had been stripped and then set on fire, but failed to burn from being so low in the water. A vessel of about 400 tons, three masts gone and bulwarks, and decks awash—name of vessel burnt off," he wrote.

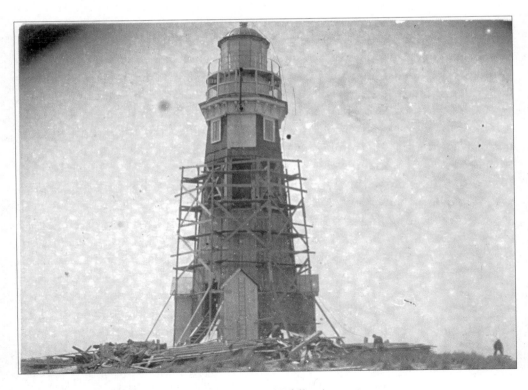

🕮 *The east lighthouse undergoing repairs in 1902 following a storm.*

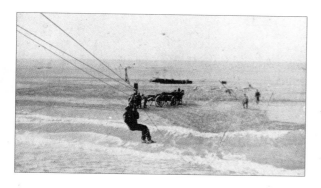

Training with the breeches buoy from the deck of the Crofton Hall, 1898.

On rare occasions the superintendent even found his own men stealing from ships they had just saved. In one instance, R. J. discovered stolen spyglasses and a cabin hatch hidden in station #2. The culprit was severely admonished and sent back to the mainland on the next ship.

Although the work of lifesaving was often heartbreaking, there were good news stories as well. R. J. proudly recorded the details of one such successful rescue on June 2, 1901:

> *At 9:30 A.M. Keeper Tobin reported a wreck on the NE Wet Bar. Ordered all hands to #4, launched lifeboat* Relief *on South side at 12:30 P.M. At 3:50 P.M. Lifeboat abreast of point of NE Bar and wrecked Brigantine about 2 miles farther out. Fog shut down thick; could not find wreck and anchored 1 ½ hours. Two boats with the crew of Brigantine came in on the north side, guided them to #4 Boat House where boats were hauled up and unloaded of baggage. All hands at #4 tonight. The Brigantine* Stella Maris *of Granville France, 260 tons, Captain Beaudry from Turks Island with salt for St. Pierre Miquelon (8 all told. All saved).*

R. J. expected his crew to be disciplined and obedient. With regular dry-land and ocean lifeboat drills, and practice with the rocket apparatus and the breeches buoy, R. J. kept his sailors fit and ready to face disaster. The men knew that, despite the danger, the simple code of courage had only one rule: "We got to go an' keep on goin' 'til we've been swamped three times."

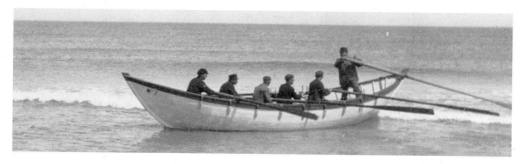

Lifesaving staff drilling rescue procedures in the lifeboat Reliance.

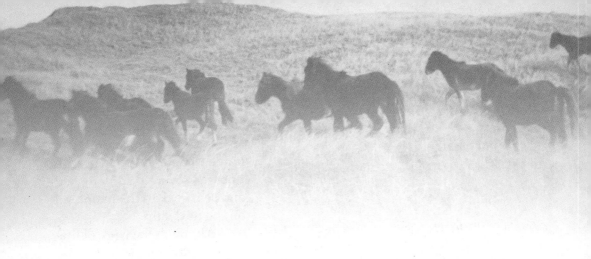

LANDMARK SHIPWRECKS

One of the most famous ships to wreck on Sable Island was the *Crofton Hall*, a four-masted, iron-hulled barque transport ship, 2,133 tons in ballast, travelling from Dundee, Scotland, to New York. The ship hit the south side of the northeast bar in the dense fog of winter in 1898. Its mast askew and the rigging hanging slack, the ship remained upright in the sand for years. Visitors to the island loved seeing it, and raced down the beach to the *Hall*. R.J. even built a salvage hut to store material taken from the ship. Mounted at the Main Station, the bell from the *Crofton Hall* rang out the call to worship every Sunday.

R. J. wrote in his log:

Early that Sunday morning, the East Lighthouse keeper spied a large square rigger on the south side of the NE bar at the end of the green. Immediately, he telephoned me at the main station. By 9:30 A.M. we had a crew on the beach with the Rocket apparatus primed and ready to go. Dick was the leader that day. He loaded four ounces of powder into the Lyle gun, attached the projectile to the

⇥ The **Crofton Hall** *at rest in the sand just south of the northeast bar, 1898.*

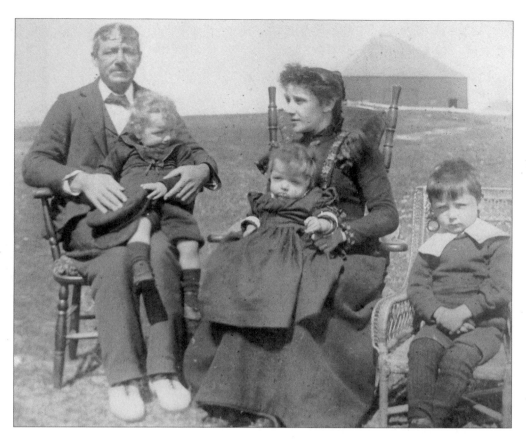

≋ Captain Thurber of the Crofton Hall *and his family were stranded on Sable Island for a month before they were transferred to the mainland.*

whip line, and shot the rocket over the wreck. The crew made secure the con-
nection on board ship, and with blocks and tackle the land crew guided a heavy
hawser line connecting the ship to the shore. Before adding any equipment, my
men guaranteed the line was securely anchored to the A frame on shore. When
all was good, Wentzell attached the breeches buoy and Captain Thurber on the
Crofton Hall *reeled it onboard.*

Captain Thurber and his family spent more than a month with the super-intendent, and his crew filled the sailors' houses to bursting. In 1898 with no wireless, they could neither inform the authorities about the wreck nor the ship's owners about their loss.

For many years, the islanders salvaged goods and parts from the *Crofton Hall*. When coal ran low in the stations, boatmen salved tons at a time from the wreck to burn in their big Scotia stoves. When buildings needed repair, they tore

⌁ *Dick and Jim Bouteillier up the mast on the* **Crofton Hall** *with Trixie and R. J. on deck, 1898.*

⌁ *Sable Island staff salvaging goods from the* **Crofton Hall***, 1898.*

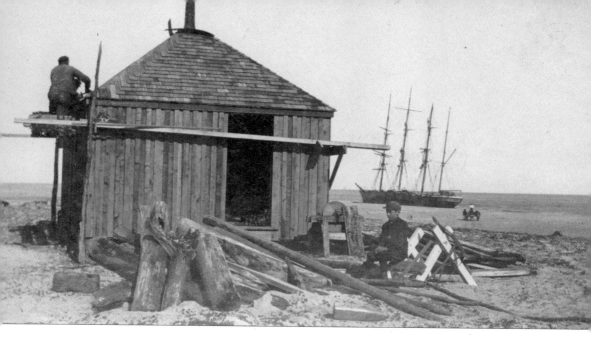

≈ *Staff carted wagonloads of cargo from the* Crofton Hall *to the salvage hut built on the south beach. The* Crofton Hall, *with its masts askew, rests in the background.*

up decking and hauled it back to shore. Vermin also made their way onto the island from the *Crofton Hall*, but the thirty cats R. J. brought from the mainland made short work of them. The foremast and bow from the iconic landmark fell following a spring storm in 1905. The entire brig finally gave in to the waves and sand in 1908, ten years after it wrecked, and washed away.

January and February, when winter darkness and fog smothered the island, were the hardest months for the people who lived on Sable Island. Such weather left unsuspecting ships vulnerable to the shallow bars and shoals lurking dangerously in their path. Wicked storms hurtled up the eastern seaboard and lashed the dunes into a frenzied maelstrom of stinging eddies. Mixed with sand, the snow hurled itself against the windows, sandblasting the glass and weathering the shingles.

And the fog.

The "death fogs" of winter lured ships into the sand's deadly embrace from which there was no escape. The lightkeeper had to remain vigilant for the strident whistle or the desperate retort of a gun from a steamer deep within the dense fog. The keeper would wait for the fog to creep away from the shore so he could confirm it was caught on the bar; otherwise the ship was beyond their reach. If the keeper was able to spot the ship, he was to contact the Main Station straight away.

The account of the wreck of the *Skidby* is legendary. On the last day of

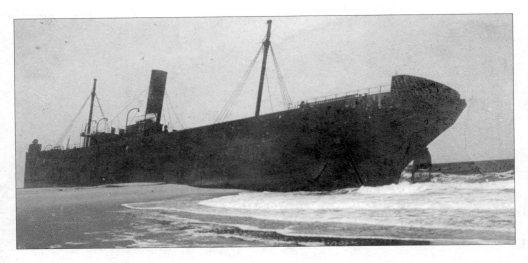

🐚 *The wreck of the* Skidby *lists seaward in 1905. With each passing decade, it sank lower into the sand.*

January 1898, the bleakest month of the year, the west lightkeeper reported a steamer's whistle off to the northwest. It blew a few times and then ceased, leading the keeper to believe it had cleared the bar and sailed off. But when the fog began to dissipate around 9:30 P.M., he could see the ship hung up on the wet sand of the northwest bar. Immediately he called the superintendent.

R. J. called all hands out. Lanterns in hand, the men slogged for hours through the wet sand, patrolling the beach from the Main Station to the point of the bar. Finally, just before 2:00 A.M., they discovered the ship: it had come off the bar and was slowly drifting down the bend of the island, almost onto the dry north beach. It was a ghost ship silently passing in front of them. They readied *Reliance* from the main boathouse, but it was not needed. The *Skidby* stuck on the beach close to shore.

Later that morning when the fog burned off, Captain Pearson of the stranded SS *Skidby* used flags to signal the station. Burrowed deep into the beach sand, he knew the ship was lost, but the crew was safe. At low tide, they walked ashore.

For two days, the *Skidby* remained close to shore on the north side of Sable Island, but it posed a threat since it was carrying flammable paints and other ballast. The crew needed to remove the dangerous material and bring all provisions ashore to be safely stowed. R. J.'s men and the ship's crew raced against the clock to bring everything ashore using the breeches buoy. They finished just ahead of a change in the weather.

Several days after the *Skidby* struck the north sandbar, the weather turned cold and the winds howled. With nothing to block the wind or slow the surf, the *Skidby* began to list heavily to starboard. Mired in the clutches of the sand,

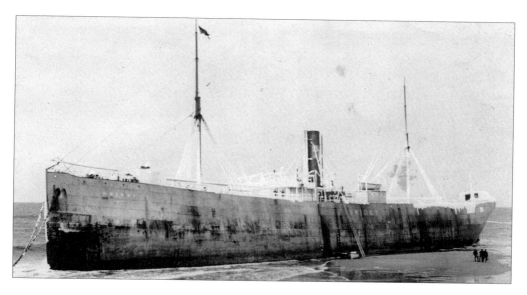

Long shot of the Skidby *following a winter storm. R.J. and Captain Thurber have just come down the salvage ladder resting against its hull.*

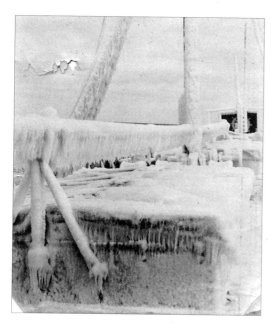

Close-up showing the thick ice coating the main mast of the Skidby, *1905.*

the ship became imprisoned. From the lookout tower, R. J. hoisted distress signals to alert passing ships of *Skidby*'s foundering, but he knew how difficult it would be for a captain a kilometre offshore to read the warning.

A different *Skidby* met the islanders the next morning. Long icicles hung in ghostly tendrils from every square inch of the ship. From the boom, skirts of heavy ice draped and fell towards the roof of the cabin. Feathery ropes of ice resembled ladders propped horizontally against the walls. The winter storm had left a beautiful legacy.

For decades, the *Skidby* remained a rusting hull locked on the north beach. Even today, after violent storms, parts of the ship are still visible.

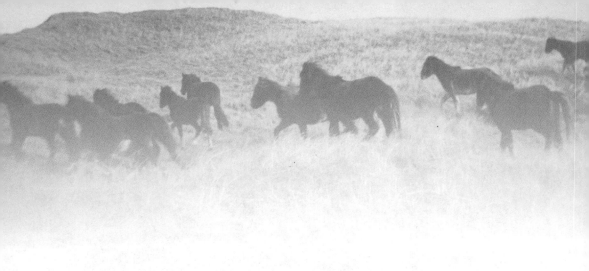

MASTER MARINER
J. A. FARQUHAR

In 1849, when he was just a lad of seven, James Farquhar's father moved his
family from Musquodoboit Harbour near Halifax to Sable Island, where he
had been hired as a government official in charge of the east lifesaving sta-
tion. James lived on Sable Island until he went to sea at age twenty-one. Growing
up on an island notorious for shipwrecks and inhabited by thousands of seals,
young Jim knew both the dangers of the sea and the riches one could earn from
it. He spent decades salving and sealing, and when he died at eighty-seven, he
had been a successful seaman for fifty-seven years.

His career at sea began in 1863 during the American Civil War as an
Ordinary Seaman on the *Prince of Wales* on a trip to Baltimore. Several ships lat-
er, he signed on to the *Emerald Isle*. On this ship, he travelled around the Horn to
San Francisco. The journey took 143 days. In San Francisco, he joined the *Derby*
and succumbed to wanderlust for three years, sailing to three continents before
returning to Halifax in 1868 to start his salvage business and learn submarine
diving.

But Captain Farquhar was not one to stay in the same job too long. When his
salvage business was well established, he built the *Cumberland* for trading in the
East Indies and the North Atlantic. This occupied him for three years, but again
he wanted to try something new. For ten years after that, he commanded the
Newfoundland to the sealing grounds up the Davis Strait to Labrador, Greenland,
and as far south as Sable Island, taking two hundred thousand seals over the
course of his career.

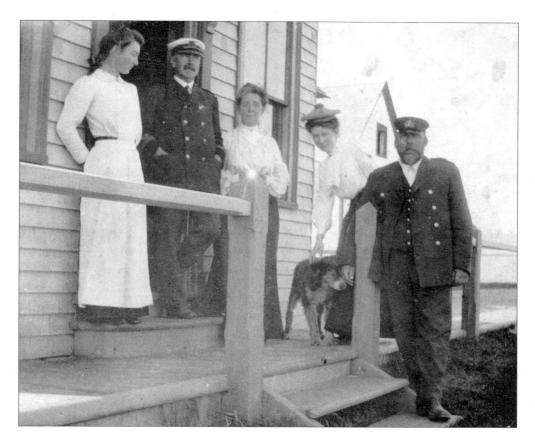

🐚 *The Captain visits the island on a salvage trip in 1901. L–R: Trixie, Captain Farquhar, Mrs. R. J. Bouteillier, Miss Ancient (teacher), and R. J. Bouteillier.*

As successful as he was, he never forgot Sable Island. Whatever ship he was master of, Captain Farquhar took every opportunity to drop anchor off the island. He brought his children to Sable Island for summer vacations, and when R. J. and his family visited the mainland, they stayed with the Farquhars at their home on Inglis Street in Halifax. Whenever he could, Jim helped islanders.

Debris regularly washed up on Sable Island. In September 1902, patrolmen reported a twenty-one-metre main boom washed up on the south beach near the *Chas H. Taylor*. R. J. dispatched a team of four oxen to haul it up to the Main Station. It would make fine flooring. Salving came in a variety of forms and captains like Jim Farquhar welcomed whatever a wreck offered. When he was appointed to salve the *Chas H. Taylor*, he discovered it was carrying frozen herring. He knew his friends at the Main Station would appreciate a delivery of fresh fish. Trixie wrote that her family enjoyed the herring for six months, until the ice in the hold melted. They were lovely and silvery—nothing like

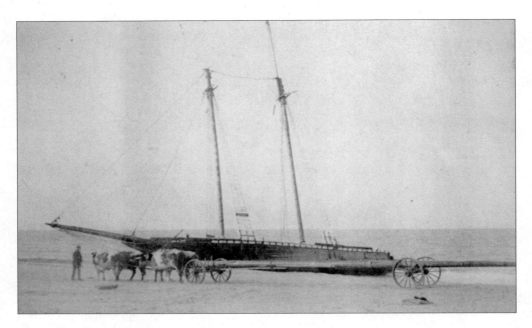

🐚 *Oxen removing a twenty-one-metre mast from the* Chas H. Taylor, *which had drifted ashore in 1897. Note the second set of wheels and frame upon which a massive piece of lumber rests.*

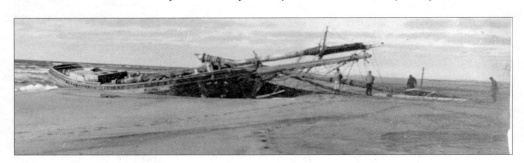

🐚 *The remains of the* Chas H. Taylor *in 1898, a year after it wrecked.*

the rust-coloured salted herring that arrived in barrels as part of the government supply.

Like all mariners, Jim had at least one good disaster story to tell. The captain was proud to share his miracle of survival with the *Atlantic Leader* on September 13, 1919:

It was on the Newfoundland *during one of our trips to the FRONT out north from St. John's. Caught in an ice floe fifteen miles northeast of the Funk Islands, a blow and severe blizzard drove the ship toward the Funks, a ledge of rocks twenty miles from the*

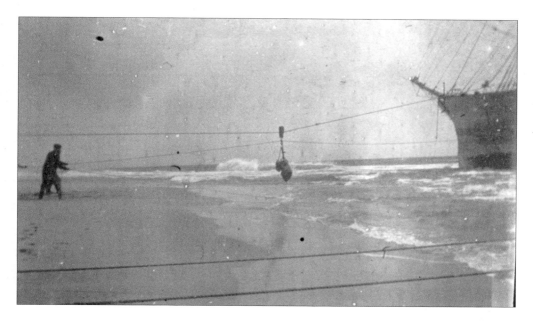

⚓ *Using the breeches buoy to remove cargo from the wreck of the* Crofton Hall.

mainland. *We couldn't move the ship and as we got closer to the ledge, the ice tightened around the ship. The wind was blowing a gale, snowing thickly and the mercury was five or six degrees below zero. It was wicked.*

She struck the rocks and went right over on her beam ends. We could see the rock under our bows as we went over and gave ourselves up as lost, when suddenly the Newfoundland *righted herself and we found ourselves on the leeward side of the island in open water. We got a hawser fastened to one of the ledges and remained there stuck in the ice and cabled to the rocks from Monday morning until Saturday.*

When we got back to Halifax and went into dry dock, we discovered a twenty-foot piece of her main keel had been torn away. Had a plank been torn off or had the rocks been jagged, not a soul of us would have been saved. Just pure luck, that.

In fact, the Maritime expression "Farquhar's Luck" is a reference to this salty captain. Next time you are in the Maritime Museum of the Atlantic in Halifax, say hello to Captain Farquhar's life-sized marble statue in his full master's uniform. He was one of the most colourful characters on the eastern seaboard, and his adventures are recounted in a book, *Farquhar's Luck*, published in 1980.

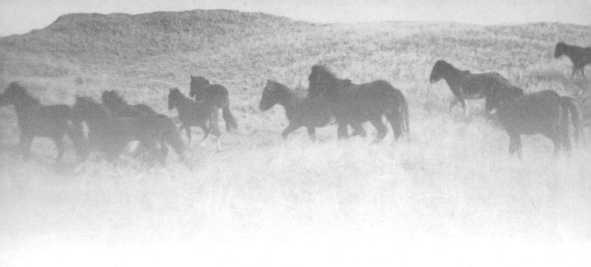

CORRESPONDENCE

O ne hundred years ago, correspondence by letter defined a man or woman. Cursive script flowed with beauty and intensity across a page. Salutations and closings were formal. Superintendent Bouteillier's thick, leather-bound correspondence book is now housed in the Nova Scotia Archives, but from his desk on Sable Island he penned letters of requests, year-end reports, and detailed accounts of shipwrecks and salving. R. J.'s correspondence book is filled with thin onionskin sheets, each page a copy of a letter. The ink is fading, but most pages are still legible.

Long before photocopiers, it was letter books—or copy books as they were called—that were popular because a writer did not have to write a letter twice in order to retain a copy of the correspondence. James Watt, well known for his invention of the steam engine, invented the process in the late 1700s, making a scribe's office life much easier.

A copy book might contain several hundred sheets of very thin and unsized paper (often called waterleaf paper) bound between two leather covers. The sheets of paper were colloquially called "flimsies." The paper needed to be made of long fibres so it would remain strong when damp; mulberry fibre was a popular choice.

With the book open, sheets of waterproof (oiled) paper were placed behind both the right-hand and left-hand pages. The letter to be copied was placed ink-side up on the right hand page. The left-hand page was dampened so it would take the copy. The book was then closed and clamped in a screw press or letterpress. When the press was opened and the original letter retrieved, the copy was dried. Ingenious!

In his role as superintendent, R. J. was the official voice of the island and regularly wrote business letters to the Department of Marine and Fisheries, the Experimental Farm in Ottawa, and the Audubon Society in Boston. But he and the

residents also sent personal letters to their family and friends on the mainland, and in those early days, it could take weeks or even months for mail to get from Sable Island to Halifax.

Each island supply ship delivered incoming letters and parcels and picked up outgoing mail destined for the mainland. R. J. kept the leather outgoing mail pouch at the Main Station, and islanders brought their letters to him to place in the pouch. There was no charge for sending mail: postage was paid by the Department of Marine and Fisheries.

Unless a passing fishing schooner launched a dory to come ashore, news did not reach the island in a timely fashion. R. J.'s firstborn, Bertha, died of typhoid fever on February 23, 1900, in Boston where she was training

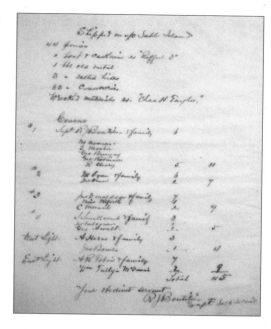

The 1891 Sable Island census as recorded by R. J. Bouteillier for each station.

to become a nurse. It wasn't until April 14, 1900, almost two months after the tragedy, that the mail satchel delivered the sad news and her Christmas letters and gifts for the family. For years, Trixie carried this bitter burden in her heart, as evidenced by this passage from her memoir:

> *The relations besieged the Marine and Fisheries if there was some way to send word down or for one of us to be taken off, but no, that wasn't possible. The government didn't spend on things like that back then. Nowadays a plane was sent if someone had appendicitis. They couldn't send that measly little steamer down that far, oh no, just seeing all that expense for one person.*

By 1910, two of R. J.'s sons had homesteaded in Saskatchewan and Trixie had travelled by train out west to help her brothers. R. J. wrote letters to them whenever he expected a supply ship.

SD Dec. 8, 1911
Dear Biddy, [R. J.'s pet name for Trixie]

I am afraid this must be another of those "witty" letters. But I have just reread yours of Sept 2 and as there may be no other chance till spring I will send you

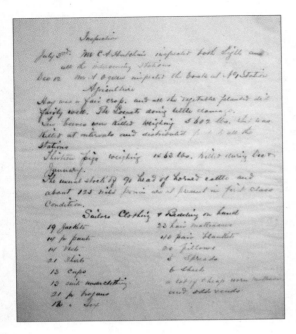

A page from R. J.'s logs listing all the sailors' supplies delivered by the supply ship.

the usual Xmas greetings. Our news is and has been nil.

Today we drove to the E Light and returned by 5 PM. We had a good beach and lake south side both ways. There is nothing new except that a more powerful lamp was placed in position August 1st which gives a much stronger light. Your news of the Dredging Captain Belanger and the others you met was interesting. Very!

Perhaps now that a wicked Tory gov't is in power it will change some of the work formerly ordered and other spots and people may get the usual rake off. The only effect the new gov't has had here is an attempt to save by cutting down my stock feed. I suppose there is the usual spasmodic attempt to retrench.

Sorry to hear of your experience in Halifax. I hope you got that molar fixed for all time. No doubt it will improve your health if treated.

All four wireless men expect relief next week and it is all guesswork yet as to who will succeed them. It seems that the bulk of the employees are new men that I never heard of. I certainly hope we will get a nice lot here this winter.

Johnny is suffering from rheumatism and only his pluck keeps him going. Chickens, kindling and the pump.

I had a letter from Clarrie last boat but have had nothing from Clarke or Dick lately. Yes, the ducks were all right. The little duck from Herring Cover or Ketch Harbour was a dandy and gave a fine lot of good eggs all or nearly all of which hatched.

It is not such an awful job to run a house and cook. When the frills are cut out it is dead easy. Why use 2 plates when one will do. Tea can be taken from a coffee cup so one will do when in too much of a hurry and no time to wash the one cup and plate. Why use it next time without prejudice. A great deal is in the mental attitude. When there is plenty of fish have fish till all consumed. Change is good but don't hanker for it every meal. Notice these latest experiences. A merry Xmas and pleasant new year.

Father

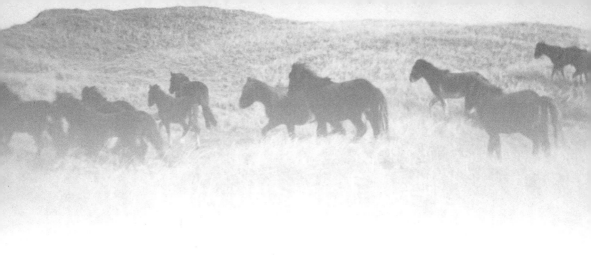

GARDENING

In the late nineteenth and early twentieth centuries, supply ships serviced Sable Island about once every two months. Sometimes, however, the interval between visits could be far longer. In 1903, R. J. noted in his logs that it had been six months and nineteen days between ships: the longest wait on record.

All islanders knew that if supply ships were delayed or unable to unload because of dangerous surf, they would have make do without the supplies. In winter, being without oil or coal caused great deprivation. Of course, fish and meat were

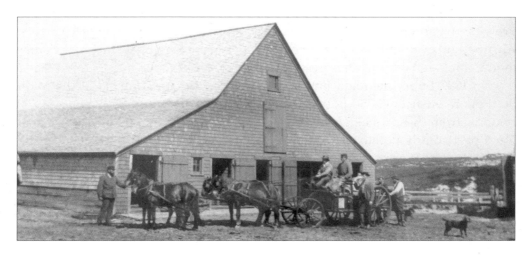

The barn at the Main Station in 1901. R. J. is holding the bridle of the first pair of horses in the team.

🐍 *Residents depended on the bounty of large gardens such as this one at the Main Station.*

abundant, but staples such as flour, yeast, sugar, and fresh produce had a finite shelf life. When stores were depleted or ruined by weather or vermin, residents could not simply go to a grocery store to restock their pantries.

In an effort to counter possible food shortages, the families of Sable Island grew large gardens that produced bushels of potatoes, beets, mangels, carrots, turnips, and even rhubarb. Islanders of all ages were kept busy during the summer and fall, harvesting and preserving their local produce.

In 1887, Superintendent Bouteillier recorded the potato yield at the Main Station: 47 bushels (2,350 pounds) from the main field and 95 bushels (4,750 pounds) from the low field. Islanders worked hard and devoured a great deal of food, particularly potatoes; no supper was complete without piles of steaming mashed potatoes crowned with rivers of gravy.

Gardening on Sable Island, however, was not easy. Because the island is composed of nothing but fine grains of sand, islanders had to add texture and substance by mulching eelgrass, along with animal and kitchen compost, into their garden plots. The quality of the soil was not the only deterrent for growing vegetables: with nothing to block them or slow them down, strong winds often screamed across the island, withering and blackening everything in their

⋙ View of the Main Station garden stretching out from the house to the southeast with Lake Wallace in the background.

wake. It's hard to believe, but Sable Island gardeners had to deal with freezer burn in the summer.

Islanders faced the greatest threat in the dry summers between 1891 and 1896, when migratory locusts (*Orthoptera atlantis*) ravaged the island's crops. They arrived from the mainland by the millions: dark clouds of frenetic wings swarmed over the island and blocked out the sun. The sound was deafening. Like drummers tapping incessant tattoos on taut drum skins, their legs crackled and hissed. When the locusts were at their worst, Trixie had to wear pantaloons secured at the ankle to prevent the creatures from flying under her skirt.

Going in and out of doors was an invitation for the flying menaces to skitter inside. Thickened with the green grasshopper slime, doorjambs had to be scraped off with a knife or the doors wouldn't shut. Residents shovelled buckets of the pests from their doorways and verandahs. Their skeletons collected in drifts along fences, walls, and walkways, and coated the entire tide line. Whether they munched their way across the island for a few days or a few weeks, when the weather changed and the fog and rain rolled in, the insects died almost overnight.

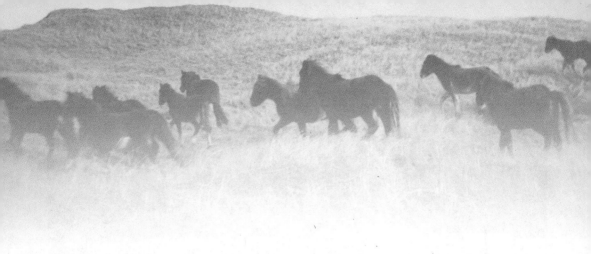

WAVE-CRESTED HIGHWAY

I
f a supply ship was unable to lay anchor, or if a surfboat could not make the trip to the supply ship because the surf was too heavy, or if weather kept the supply ship at port in Halifax, Sable Island residents did not receive food, messages, fuel, or medical supplies. They were on their own.

It's hard to fathom such isolation. More than a hundred kilometres from anywhere, islanders could only wait. One year, residents almost starved when the supply ship did not arrive for six months and nineteen days.

It wasn't only food, supplies, and mail that islanders anxiously awaited from the mainland: unless a nearby fishing schooner sent a crew ashore, islanders

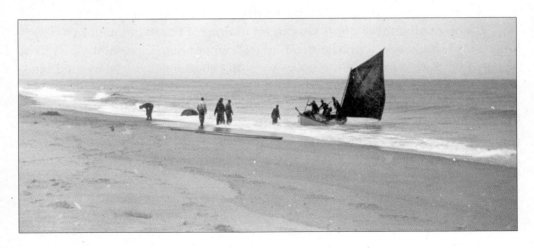

⤳ *The small-craft dispatch is almost upset by a wave, 1893.*

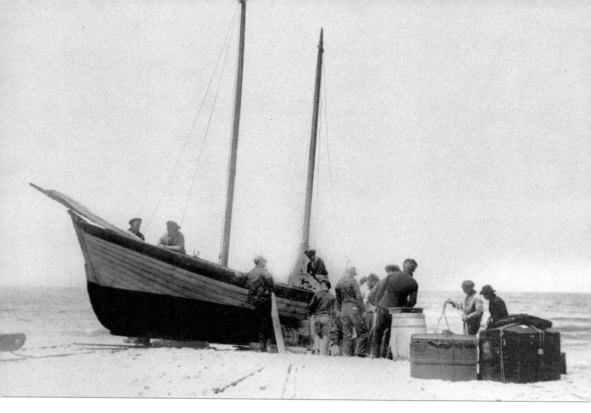

didn't know what was happening in the rest of the world. On October 26, 1901, R. J. wrote, "American Schooner *Arbitrator*'s crew ashore at East Light. They bring news of the assassination of President McKinley, of the defeat of Lipton's yacht, and that smallpox exists in Boston, Yarmouth and Halifax."

The supply ships had to be gutsy vessels. They were operated by the Dominion government, and were often icebreakers, revenue cutters, or heavy tramp steamers. Some of the most familiar ships to Sable Islanders had names like the *Daring*, the *Stanley*, the *Aberdeen*, and the longest serving steamer, the *Lady Laurier*, affectionately known as the "LR," its call letters once it was outfitted with wireless in 1905.

In good weather, the trip from Halifax to Sable Island took about sixteen hours. The ship would steam past McNabs Island in the Halifax Harbour and set its course for the southeast. The next morning, a few kilometres off the sandbar, it would sound the horn announcing its arrival. It daren't come closer than a kilometre offshore for fear of grinding its keel into the wet bar. Once safely anchored, the superintendent would dispatch a surfboat to the supply ship. Cargo, mail, and passengers would be offloaded and, depending on the weather, the captain might come ashore for a quick visit, a change of pace, or a welcome

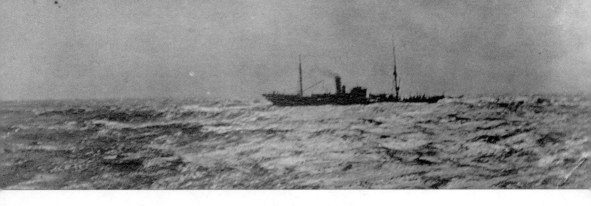

≈ *The supply ship* Lady Laurier *waiting offshore to receive the surf boat, 1905.*

break. When the surf was too heavy, R. J. used flags to signal coded messages to incoming supply ships.

It was the superintendent's job to allocate supplies to the islanders. In this capacity, R. J. kept meticulous records. He tallied human and animal populations for the yearly census. He ordered whatever the islanders needed. Letters left on the flimsies in his correspondence book show the details: the census, stores, agriculture, inspections, sailors' equipment, food, and fuel. Sometimes the Main Station staff loaded a small ketch with supplies and sailed down Lake Wallace to the mid-island stations.

Often the supply ships had other emergency duties. If a buoy broke free from its mooring the supply ship captain would have to locate it, take it into Halifax for repairs, or re-anchor it. Incorrectly placed buoys could spell tragedy; navigators relied on them to warn of the dangers below the water's surface.

> Wind S. High. with Heavy Surf on S shore.
>
> Three Hogs slaughtered .
> Steamer "Lansdowne". signale off the
> Main Station about 3 P.M. Telegraphed
> with Code from Staff. Too high surf
> to go aboard. Steamer anchored off
> for the night.

≈ *Entry in R. J.'s log noting communication by Morse code with the* Lansdowne, *1884.*

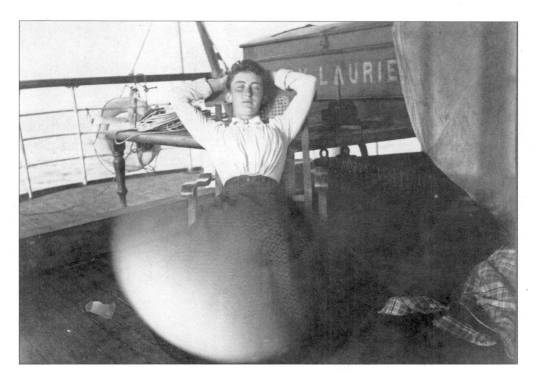

Trixie relaxing on the Lady Laurier *bound for the mainland, 1903.*

Steamers that serviced isolated outposts like Sable Island were welcomed like old friends. The drone of the whistle sounding the arrival of the supply boat was very exciting for all island residents: perhaps the superintendent was welcoming a new staff member, a mother was expecting an order from Eaton's, or a young boatman was hoping for mail from his sweetheart. The supply ship also ferried grim news to the mainland—the death of an islander, details of a shipwreck, or the dismissal of a sailor for looting.

A trip off the island meant residents could dust off the sand and experience life on the mainland for a few weeks or months. With her camera in hand, young Trixie would often be welcomed at the government dock in Halifax by her grandparents, an older brother, or any of the young wireless men she met following the installation of the wireless station in June 1905.

DOMESTIC LIFE

I t was a good thing that R. J. was a carpenter by trade. When his family arrived in 1885, the only house available for the entire family was the former officers' house, as the superintendent's house had burned down months before. But it was no matter, as long as they were together.

On the day the Bouteillier family landed on Sable Island, Trixie and her brothers flew around in the sand and fields. Sable Island was a gem of a playground that early June morning. But in her memoirs she wrote about how her mother reacted to their new home:

> I don't remember much more about our arrival, except there was a terrible lot of fleas and cockroaches in the house. My mother was horrified. Just horrified. We set to work thinking it was great fun killing fleas in the morning when we woke up. Well, naturally, the fleas and the cockroaches soon became a thing of the past.

Repairs happened quickly. In the summer of 1885, R. J. built a large addition to the back of the house. It was the main work area for many domestic chores. Trixie's mother, Ellen, set the treadle sewing machine next to her bins of fabric, ironing pads, and sewing projects under the eastern window. Rows of cupboards hung along the opposite wall and below them were barrels filled with flour, salt, oatmeal, and other staples.

Trixie found island life very much to her liking. She basked in the freedom and independence afforded by her island home. She cared for her horse, Midge, and expertly drove her one-horse trap to the strawberry fields on Halfway Hills where she picked small Sable Island strawberries, or met the families from the

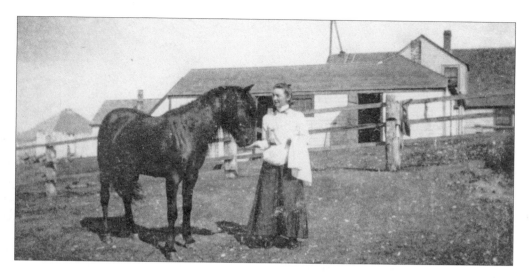

🖎 *Trixie feeding her horse, Midge, at the Main Station barn, 1900.*

east side in August for blueberries. Come September, jars of preserves lined the cellar shelves.

Although shelves upon shelves of preserves, root cellars full of potatoes, carrots, beets, and other vegetables, and a smokehouse full of salted fish sounds romantic and rustic, it entailed a great deal of work. Trixie often wrote that she would be happy if she could rest for just one week without any work.

A huge Scotia stovetop range took up most of the north wall. A warming drawer sat above a cast iron cooking surface that ran the entire width of the stove. A large water tank extended from the right side of the contraption, and a massive oven was next to the firebox. Pots, pans, cooking utensils, cups, and kettles hung within easy reach from large hooks on the wall near the stove.

Two large laundry tubs sat against the south wall, and in the middle of the room was a huge butcher block table, the heart of the room. As Trixie grew, she helped her mother and the cook with all the household duties.

Making three meals a day, seven days a week, for twelve to fourteen hungry people took a great deal of organization and planning. Each day, Trixie made at least five or six loaves of bread. She kneaded the dough on the worktable, patted it into shape, put the flowered balls of dough into greased pans, and set the pans in the warming drawer to rise. When the rising dough mushroomed the cotton covers by a few inches, the loaves were ready for the oven. On any given day a pot of stew, a crock of beans, a kettle of chowder, or a tureen of potato soup simmered on the stove. The kitchen was always warm and filled with comforting smells of home.

Doing laundry on Sable Island was a full-day event. Trixie started by lathering the shirts, pants, skirts, and tunics with soap. She then scrubbed the clothes

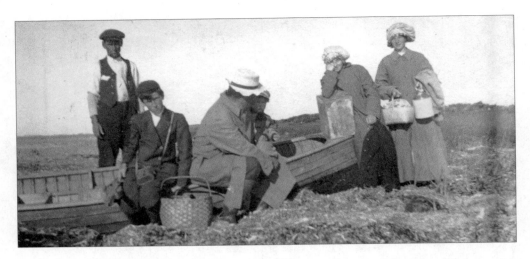

Harvesting blueberries in the barrens with the residents from the east side of the island, 1900.

up and down along a rippled glass washboard set in the hot water tub. Next, she rinsed them in the cool water tub, wrung them out, and hung them to dry over the fence that ran along the south side of the house. The salt water on sailors' uniforms or R. J.'s jackets presented an extra challenge, as did the stains on the women's aprons from picking berries, but Trixie had a few tricks up her sleeve. She often dropped blue indigo cakes into a tub of white shirts and blouses to keep them brilliantly bright.

Once they were dry, the shirts and blouses had to be ironed. This meant a hot fire had to rage in the stove in order to heat the sad irons. Many people think antique irons were called "sad irons" because women felt sad when they had to do this wretched chore, but that is just a myth. The moniker actually refers to the word's Old English roots—*sald* means "solid" and these irons were definitely that. Made of heavy cast iron, they weighed anywhere from five to fifteen pounds. Before detachable wooden handles (which didn't heat up like the old iron handles), women had to use thick potholders simply to hold the irons. Lifting and moving them over clothing took a lot of strength. Many blisters likely accompanied this household chore.

The sad irons Trixie used were flat and triangular, fitted with a wooden handle. Because the irons cooled so quickly, she needed two or three. Trixie set them on the top of the stove to get hot and when the one she was using cooled, she set it back on the stove and used a second one. No wonder "ironing day" was just that: a full day's work.

After the laundry, ironing, and pot washing were done, the floors swept, and the dishes put away, Trixie took up her needle. There was always something that needed mending or stitching. When she was just a teenager, she made her

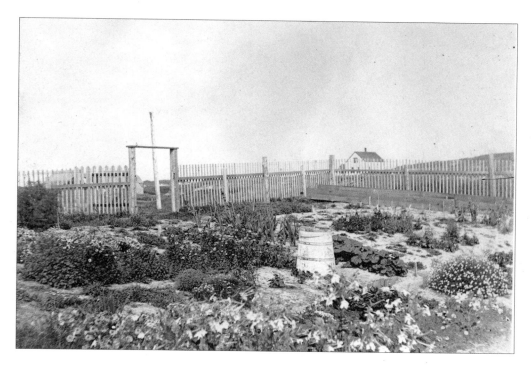

Trixie's sheltered flower garden at the Main Station, 1906.

first coat, which entailed drawing out the pattern, cutting the fabric, and sewing it together. She received many compliments when she wore it for the first time on a trip to the mainland. While she and Tom Davies (son of Sir Louis Davies, former minister of Marine and Fisheries) were waiting for the surfboat to take them to the supply ship, he commented on her new coat. Trixie wrote in her memoir: "I made the coat, my first and was quite proud of it. It looked fine with my new ostrich scarf"

In addition to the endless hours of cooking, cleaning, and other household duties, Trixie still managed to find time for gardening. Of course, most plants grown on the island were for human or animal consumption, but in a plot protected behind a fence, Trixie grew many decorative flowers at the Main Station. All her life, no matter where she lived, she said her garden was her treasure. And it was no different on Sable Island: her flower garden was filled with irises, lilies, poppies, and countless other perennials. They created a welcome symphony of colour in an otherwise bleak environment when they bloomed on the wide verandah of the Main Station. The garden required hours of tender care.

Even bathing was just another job in an unending to-do list. At the end of every chore-filled day, lulled by the constant sound of the wind, sleep came quickly.

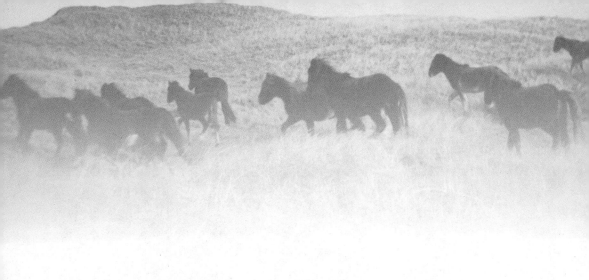

SCHOOL

For years, the island's superintendent hired tutors for the children. It was the teacher's job to travel from station to station, giving lessons. It was not until 1901 that a real schoolhouse was built at the old station #2.

R. J. requested his brother, Rupert, the superintendent of schools in Londonderry, Nova Scotia, advertise for a teacher willing to work on Sable Island. A young woman, Miss Ancient, daughter of Reverend William Ancient, applied for the job and came highly qualified, having been raised in a "strong Christian home." She was used to following strict rules, had a high standard for good behaviour, and had received a fine education herself.

Miss Ancient's father's reputation preceded her. Twenty-eight years earlier, on April 1, 1873, the luxury steamship SS *Atlantic* of the infamous White Star Line ran aground on Mars Head in Lower Prospect, Nova Scotia. It was the worst single-vessel marine disaster to occur off the Canadian coast prior to the sinking of the *Titanic*. Of the 952 souls on board, only 390 were saved. Reverend William Ancient, then an Anglican clergyman for the Terence Bay Mission (known as Tern's Bay at the time) led a team of local fishermen in the rescue. R. J. believed if Reverend Ancient's daughter had any of her father's tenacity and strong will, she would be a fine candidate for the position of Sable Island's schoolmistress.

Miss Ancient arrived in May 1901 with her trunks. She inspected the schoolhouse, which the carpenter, Mr. Egan, had been working on for several weeks, and was pleased with what she found. The first day of school was July 10, 1901, with three students in attendance.

❧ *The old station #2 is transformed into a one-room schoolhouse, 1901.*

Depending on the time of the year, the population of the school fluctuated between five and twelve students. Sometimes, the weather made it impossible for the children to get to the schoolhouse or parents needed their children at home to help with berrypicking or haying. Other times, children were off the island for medical treatment.

The schoolmistress lived at the Main Station on weekends but every Sunday, she made the five-kilometre trek by pony to the school. From Monday to Friday she gave the children lessons, fed them, and watched over them at night. Eventually, workers installed a phone at the schoolhouse so Miss Ancient would not feel so isolated.

The teacher followed the Nova Scotia school curriculum. McKinlay's "Map of the Maritime Provinces of the Dominion of Canada" hung on the wall, with Nova Scotia clearly visible. Classroom provisions—textbooks, exercise books, and the notorious strap and cane—came on supply ships to the island.

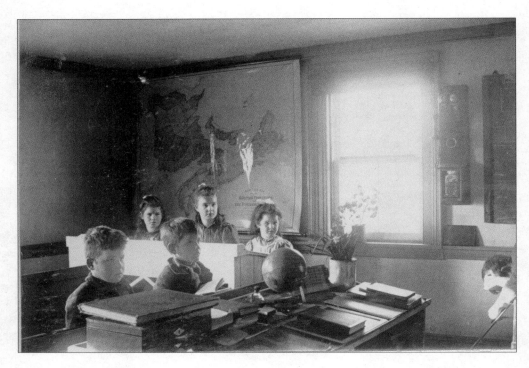

Students inside the schoolhouse in 1901. Note the telephone and the map of Nova Scotia on the wall.

Of course there were many stories and rumours about Miss Ancient. Sometimes, parents refused to send their children to the school because they believed she was too strict, often caning students for misbehaviour. But for the most part, school on Sable Island was a success.

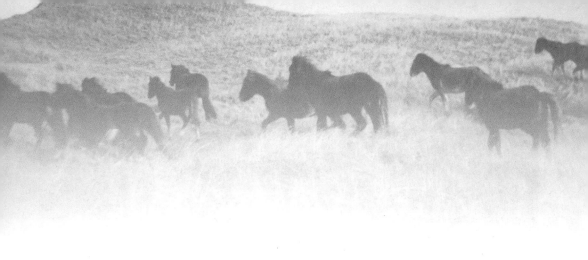

EROSION

I n 1886, Simon McDonald of the Institute of Natural Science predicted that within one hundred years, Sable Island would sink and create the most treacherous sandbar in the world. 160 years on, the island has proved him wrong—at least so far.

R. J. was vigilant in tracking the changes of the island, lying naked as it did to the sea: the currents, the tides, and the constant wind. Each year, he recorded changes in submergence or emergence of sandbars, changes in the height of dunes, and the rising and falling water levels of the ponds and Lake Wallace. Facing little resistance, high winds propelled the dunes inland and parched the fields with smothering sand.

Sable Island was colloquially known as "the Island of Shifting Sands." Winds, tides, and currents posed many erosion hazards. On many occasions Trixie used her camera to capture the island's vulnerability to the elements. After a wild storm, seawater would hurtle over the dunes and fill the ponds. In March 1906, R. J. reported that a channel had been cut through on the south beach, abreast of Main Station, causing the lake to run down to tide level. He knew all too well that if the protective dune on the south side disappeared, Lake Wallace would eventually disappear too.

At the eastern end of the island, Whalepost also fell victim to the vagaries of Mother Nature. Each December, R. J. and his family used to ride to the Whalepost valley and collect lowbush junipers for lacing their Christmas table. In later years, they watched helplessly as the sand blew rising drifts into the valley from atop Whalepost dune, eventually smothering the juniper bushes.

⇜ Water inland following storm.

In a diary entry from January 1895, R. J. wrote: "The sea is already 5 feet from the base of the rescue hut. Will likely sweep the building away in the next high tide." In 1910, the keeper from the east lighthouse reported what looked like a hulk or derelict on the northeast wet bar. Upon investigation he realized it was not a ship, but a new spit of sand looming out of the fog with many seals on it. The eastern end of the island appeared to be growing.

Each year, R. J. measured and recorded details about the sandbars. Although it was a crude science in the nineteenth century, R. J. attempted to keep detailed records of the changing shape of the island. He used the lighthouses as checkpoints from which to track erosion. The west end of the island suffered most. Between 1883 and 1894, the surf completely washed away that end—the west lighthouse tower and keeper's home had to be relocated eastward many times.

Before the west lighthouse tower fell, the men were able to remove its lantern and the wooden cladding that covered the metal frame. Once the ocean undermined the concrete foundation, it was only a matter of days before the entire framework crumpled seaward. The brutal regiments of erosion and submergence clawed away at the structure until it was inexorably sucked out to sea.

In 1888, R. J. cited the dangerous encroachment of the sea and the subsequent work to move the west light:

> *February 12—West lightkeeper reports 20 feet washed away. Less than 30 feet to the buttress of the tower.*
> *February 15—Sending down Lantern of the West light.*
> *February 27—Only 8 feet left south of the buttress.*
> *June 6—Carpenters finished pulling down West light.*
> *September 4—Finished painting tower of new West light.*
> *June 21—Picnic at the new site of the West End Light.*
> *October 20—New light relighted and in full operation.*

⚐ *Whalepost in 1909. What was once a nice valley is filled with sand blown from the dunes.*

R. J. relied on a click wheel (sometimes called a hodometer or surveyor's wheel) to plot the position of each lighthouse in relation to the water. Think of this mechanical measuring tool as a unicycle attached to a handle held about waist high. As the wheel is pushed along a flat surface, each rotation calculates the distance of the wheel's circumference. Most were almost one metre around. A mechanical counter clicked off each revolution, thus tallying the distance.
In his journals R. J. wrote, "from the Light to the end of the land (980 yards) and to the point of the dry bar (1,507 yards). Beyond this distance lies the crashing shoals of the wet bar."

In R. J.'s time on Sable Island, the island consisted of two ridges of dunes, running east to west, joined in the middle by valleys of varying width. The south dune, which prevented Lake Wallace from filling with seawater, was often breached in wild storms. R. J. wrote:

> *August 26, 1887—Very heavy sea on the South side. Washing away the bank with old flagstaff. Expected to lose the south garden on the night's high tide.*

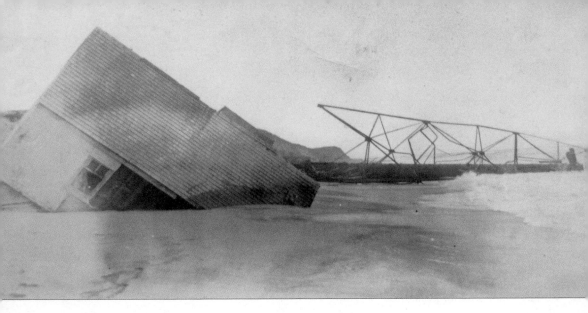

≈ The west lighthouse tower succumbing to the relentless waves.

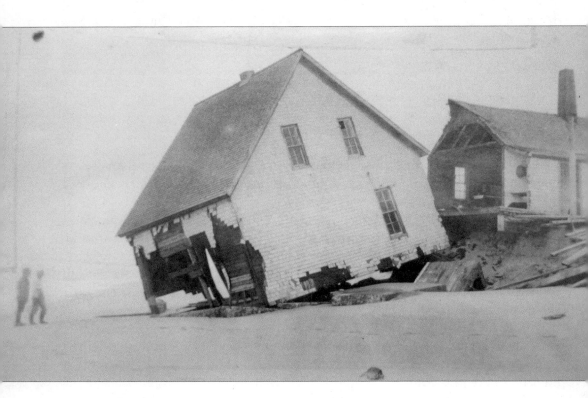

≈ The dwellings at the west light being sucked into the sea following yet another violent storm.

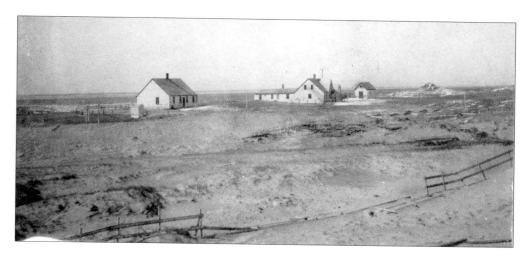

🍃 *Sand blown over the dune crushes the pasture fence at the Main Station, 1893.*

December 20, 1888—Lake higher than ever before and banks falling all along the margin.

December 27 1890—The last vestige of land opposite the Main Station, south side disappeared. Only sand from the West End to the twin hummocks opposite Green Head.

Within three years, the westerly edge of the south dune near the Main Station became a memory, leaving only a wide sandy beach where the western waters of Lake Wallace once welcomed boaters and swimmers. As a consequence, the north dune and the valley of the Main Station were left perilously unprotected from storms and vicious tides.

For decades R. J. monitored the changing landscape of Sable Island. Because of his diligence, his records provide a baseline for all further studies of the sandbar in the North Atlantic.

🍃🍃

To see these (and many other) amazing and dramatic photos of Sable Island, be sure to check out the collection at the Maritime Museum of the Atlantic on Lower Water Street in Halifax.

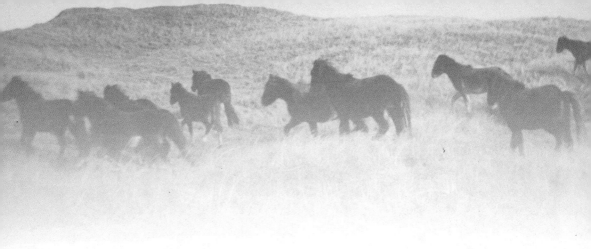

FAMOUS VISITORS

Over the years, many famous people crossed the shoals of Sable Island. During his tenure, R. J. welcomed ornithologist Dr. J. Dwight (1894), inventor Dr. Alexander Graham Bell (1898), and botanist Professor Macoun (1899). Although these three men came to the island for very different reasons, each was specific to Sable Island: to study the migration of the Ipswich (Savannah) sparrow, to search for shipwreck victims, and to collect and tabulate specimens of flora and fauna.

Jim Bouteillier out birding in 1899. In his right hand, he holds his Audubon bird book.

DR. J. DWIGHT: 1894

Sable Island is a welcome landing spot for hundreds of species of birds on their migratory journey south. Many species of tern, swallow, duck, plover, and sparrow touch down for a few weeks or months. R. J.'s children were great observers of the many birds that visited the island—they could recognize their songs and knew their habits.

Quivering masses of white and black, millions of terns alighted on Sable Island each year. Trixie remarked that they blocked out the sun like undulating flags, their cries and swoops filling the sky with music.

One of the island's most famous birds is the Ipswich sparrow. This little gray bird doesn't nest anywhere else in the world but on Sable Island. In 1894, when Dr. J. Dwight visited the island from the Nuttall Ornithological Club in Boston, the children were enraptured. He was there to study the sparrow and confirm it spent the winter on Sable Island. Trixie and her younger brothers, Dick and Jim, were avid birders who collected skins of many species. They helped the ornithologist find the finely constructed nests hollowed out in old pieces of wood, or hidden in the grass. During the ten days Dr. Dwight was on the island, he collected fourteen skins and snapped many photographs.

Beneath this beautiful plate of the Ipswich sparrow drawn by William Stone in 1895 for Dr. Dwight's book on the Sable Island sparrow, Trixie wrote the words

Island Pond near the Main Station—a place to avoid during nesting season.

⊰ *Plate of the Ipswich sparrow in Dr. J. Dwight's book,* The Ipswich Sparrow and Its Summer Home, *1895.*

"*Ammodramus princeps*, (Maynard)," the genus and species names. She learned them in 1894 when she was fourteen years old, and in her memoirs recorded eighty years later, she could still recite the details.

DR. ALEXANDER GRAHAM BELL: 1898

Sable Island is an anomaly because of its isolation and unique topography, and it has garnered considerable infamy from the number of shipwrecks on or near its tentacle-like sandbars. In 1898, Dr. Alexander Graham Bell, his wife, and their daughter arrived on Captain Farquhar's *Harlaw* in search of their friends Mr. and Mrs. Pollock, who were unlucky passengers on the SS *La Bourgoyne*. It had gone down three weeks earlier on July 4, sixty nautical miles south of Sable Island. Recklessly travelling at eighteen knots in dense fog, *La Bourgoyne* rammed a British sailing ship, *Cromartyshire*.

The *Cromartyshire* did not sink, but *La Bourgoyne* suffered a mortal wound. After the collision, *La Bourgoyne* disappeared into the fog and attempted to beach on Sable Island, but the engine room had flooded causing a loss of power. As a result, the ship floated aimlessly until it sunk. No hope of reaching Sable Island.

Believing *La Bourgoyne* had continued safely on its way, Captain Henderson of the *Cromartyshire*, although angered at the situation, gave no further thought

≈ *Dr. Alexander Graham Bell's Sable Island kite experiments, 1898.*

to the fate of the culprit. He was more interested in his own ship. He hove to the *Cromartyshire* to survey the damage, but as the fog slowly lifted, lifeboats from the *La Bourgoyne* began appearing off his bow. At least 562 of the 730 souls on board were lost. Twelve percent of the passengers and 50 percent of the crew survived. A subsequent inquiry found the captain of *La Bourgoyne* at fault, but the verdict brought little solace to those who had lost their loved ones.

Dr. Bell and his wife were desperate to find any trace of their friends, but by the time they arrived on July 28, there was little hope of them finding anything but heart-wrenching debris.

In 1898, wireless communication was still seven years away from coming to Sable Island. Isolated and held captive by the vagaries of the weather, the isle of sand lay in wait for its next victims. Mightn't something be done?

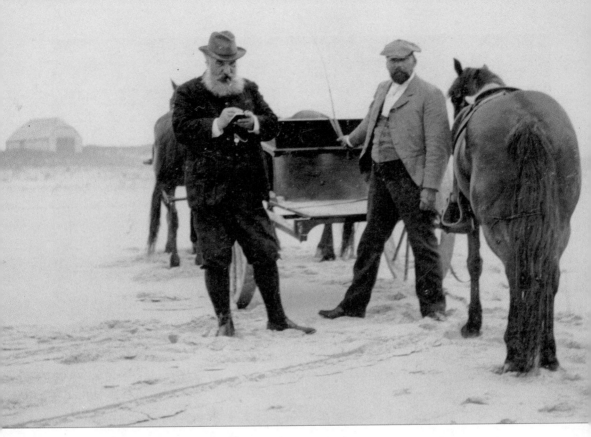

❒ *Dr. Alexander Graham Bell (L) and Superintendent R. J. Bouteillier, July 1898.*

Although the visit was marred by grief for the Bells, Superintendent R. J. Bouteillier and the famous inventor spent many an evening thinking of ways to improve communication between the island and the mainland. They experimented with kites and message floats, utilizing the currents to send news.

One evening, the two men recalled the carrier pigeon project Major-General Donald Cameron had initiated in the early 1890s. He had chosen isolated Sable Island as a testing ground for his National Messenger Pigeon Service. R. J., desperate to develop rapid communication between the island and the mainland, agreed to participate. Although some of the pigeons were valiant flyers and did manage to reach the mainland on their test runs, it was in the wake of a very real shipwreck that they failed. The Department of Marine and Fisheries terminated the testing in 1894—the same year R. J.'s wife, Ellen, became gravely ill and her husband had no means to contact a doctor on the mainland.

Like pigeons, kites were never used to send messages from Sable Island, but inventors never stopped searching for means to improve communication between ships at sea and from ships to shore. In the Paris Exposition of 1900, the

Pollock family, following the tragic loss of the *La Bourgoyne* in 1898, launched a competition: they encouraged designers to create a communication device for use in marine disasters, in hopes of preventing collisions and wrecks at sea. A year later, the young Guglielmo Marconi would successfully send messages without wires or cables. The dream was not so far-fetched after all.

PROFESSOR JOHN MACOUN 1899

Professor John Macoun was an eccentric field naturalist employed by the government of the Dominion of Canada. He and Laurence Tremaine arrived on Sable Island aboard the *Aberdeen* on a fine morning in July 1899. Macoun had selected Sable Island as the destination for his 1899 annual summer field trip.

The professor and his assistant stayed at the Main Station as R. J.'s guests for six weeks. During that time, Macoun was often seen wading in the ponds or walking along Lake Wallace, a bulging specimen bag slung over his shoulder. In the evenings he recorded his findings, which he later published for the Canadian Geological Survey.

Sitting on the Main Station verandah, surrounded by any number of the island children, the professor would regale them with stories of the amazing creatures to be found on their island. A teacher at heart, Professor Macoun left a long message in the visitor's book. He encouraged the children, despite living in such a remote area, to look to nature as she was the best teacher.

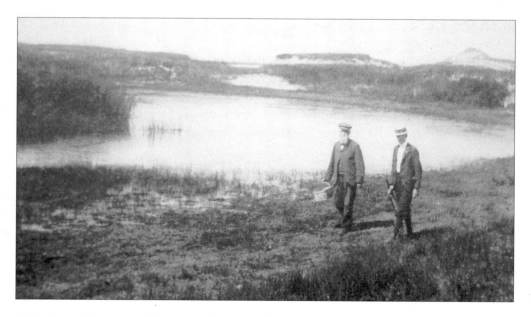

Professor Macoun and Laurence Tremaine (his assistant) collecting specimens, July 1899.

🐚 *Professor Macoun gathering tern eggs in Island Pond, July 1899.*

Over his long career, Professor Macoun collected and catalogued enormous collections of both vertebrate and non-vertebrate species, as well as plants and birds from British Columbia to the Maritimes. He presented his findings to academics across the country and for years, his word was the standard against which all other naturalists were measured. Even after a stroke in 1912 forced him to move to Sidney, British Columbia, Professor Macoun continued to work collecting specimens along the shoreline and writing his autobiography.

Professor Macoun inspired the young botanist Harold St. John to conduct a study on the flora and fauna of the specific ecosystem found on Sable Island. In 1913, St. John spent a summer on the island collecting specimens. In 1921, he presented his findings to the Boston Society of Natural History. Today, naturalists still refer to his work and hold him in high regard.

Although Macoun never returned to Sable Island, the morning of his departure a mare was due to give birth. To be sure no one would forget the white-bearded naturalist's visit to Sable Island, R. J. named the foal Macoun.

🐚 *Professor Macoun's signature in the Sable Island guest book, written in August 1899.*

TREE EXPERIMENTS

Professor Macoun recalled his 1899 visit to Sable Island with great fondness, and he became a loud supporter of the Dominion government's proposed experiment to grow trees on Sable Island. On May 16, 1901, botanists Dr. William Saunders of the Ottawa Experimental Farm and Lieutenant Colonel Francois Gourdeau of the Department of Marine and Fisheries travelled on the SS *Minto* to Sable Island with high expectations. Hundreds of crates of tender seedlings sat stacked on the beach waiting for the oxen wagons.

The Dominion botanists believed that if they could coax the trees to grow on Sable Island, erosion would be halted, thus saving the island from sinking

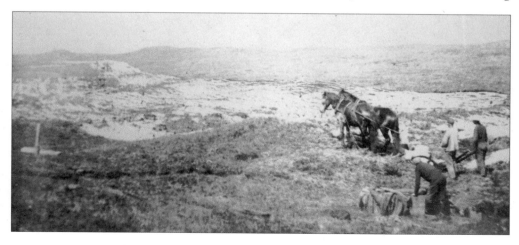

Plowing fields to plant seedlings in the great tree experiment of 1901.

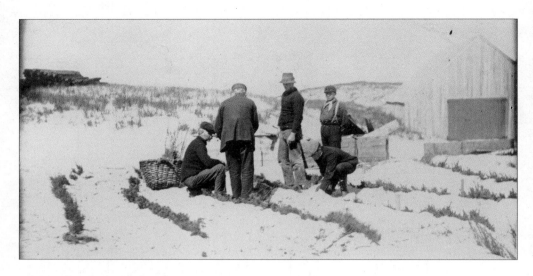

Heeling in the trees in preparation for planting, May 1901.

below the surface of the ocean. The belief was that tree root systems would bind the sand together, preventing the sand from drifting, thus preventing high tides from opening channels to the lake. In both scenarios, the botanists believed trees would be the glue that would keep the island intact. The greatest fear was always the eventual submergence of the island. If it were ever to happen, the resulting shifting shoals lurking below the water's surface would be a far greater danger to navigation than the island, which rises about twenty-three metres above the surface.

This well was dug specifically for watering the trees planted in the arboretum at the Main Station in 1901. On the right Jim Bouteillier is seen atop his horse, Jerry.

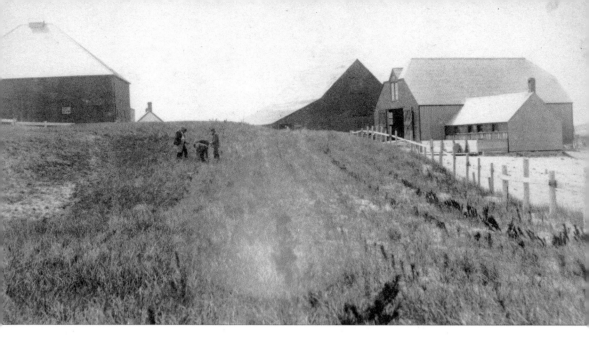

⅋ *Planting trees at the Main Station field, 1901.*

The project was monumental: of the eighty-eight thousand saplings, sixty-eight thousand were evergreens (of twenty-five different varieties) and thirteen thousand were deciduous trees (of seventy-nine different varieties) including currants and apples. The shipment also included fifty pounds of seed.

Once the trees arrived, there was no time to waste. Saunders and Gourdeau selected five areas to plant. Harold St. John recorded the details for the Boston Geological Society:

> *300 were planted near the East End Lighthouse, about 1,000 at No. 2 Life Saving Station, about 5,000 at No. 3 LSS, about 3,000 at No. 4 LSS, and the remainder at the large plantation newly named Gourdeau Park, a section near the Wireless Station formed of low rolling dunes covered with a thick mat of trailing grasses.*

The valley near the Main Station, which R. J. called "The Arboretum," was first planted with deciduous and ornamentals. Due to the huge number of saplings, some trees were heeled in near the lower warehouse until it was time to plant them. The job was enormous but R. J., his men, and the government workers were diligent. By June 17, all eighty-eight thousand trees were in the ground and the fifty pounds of Maritime Pine seed was sown in the main field at station #1.

The first southwest gale proved to be a fatal test for many of the little trees. When R. J. checked the ornamentals, their tender new leaves had turned to brittle brown spikes. It was as though a fire had run close to the trees and scorched

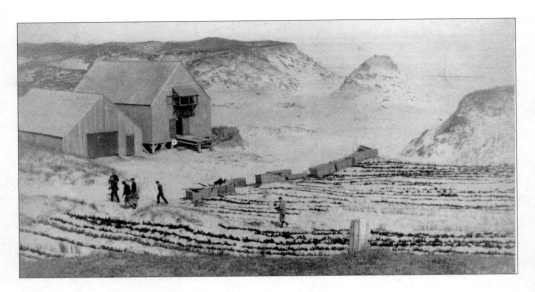

🍃 *Planting trees at the lower field of the Main Station, 1901.*

them. The high winds had rotated their slender stems in the sand, burrowing out circular holes through which dry air sucked the moisture from the fragile roots. They withered and died within the week.

Every month, the superintendent charted the progress of the little trees. He was diligent in his care: in late fall, R. J. covered the trees with barrels and boxes to protect them from winter gales; in spring, he cut the grass between the trees; in a very dry summer he sunk a well alongside The Arboretum, fitted with a pump and spouts, to water the saplings.

The spruce trees were the last to wither and die. In just four years, almost all of the eighty-eight thousand trees had succumbed to the weather. On June 7, 1906, R. J. tore down the Gourdeau Park fence.

During his 1899 visit to the island, Professor Macoun recorded details about two trees: a willow and an elm that the superintendent had planted fourteen years earlier in 1885 when his family first arrived. In the shelter of the adjacent fence, they flourished. Every spring, they sprouted tender leaves, but any tendrils that grew higher than the top rail of the fence often withered or were small and misshapen. Trixie's geese and ducks contentedly squawked about in the shade of the staunch little willow, one of the few trees on Sable Island.

The early nineteenth century was a time of great interest in finding, collecting, and recording the flora and fauna of all areas of the world—the more exotic the better. Botanists from Canada and the United States were part of these great collecting projects and Harold St. John, following in Professor Macoun's footsteps, was one of these early scientists. Although R. J. had retired as superintendent

⁀ The lone willow tree in Trixie's flower garden, 1895.

by the time St. John visited the island in 1913, R. J. returned to help the young botanist with his research. At that time there were no more than seventy-five trees from the infamous 1901 tree experiment still alive.

In 1921 the Boston Geological Society published St. John's findings regarding the plants of Sable Island, in particular the tree planting endeavor. His Sable Island work is still housed in the Gray Herbarium archival collection in Boston, Massachusetts.

Perhaps if each tree had been anchored with double stakes to keep it from moving in the wind, or if some type of protection could have been afforded the tender saplings, they would have been more successful. Regardless, Sable Island was having nothing to do with trees cluttering up its hills of waving grass.

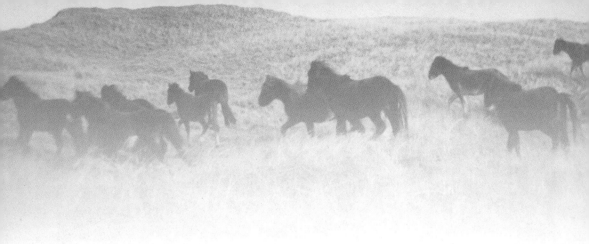

HUNTING

At various times in Sable Island's human history, foxes were a big part of the wildlife population. In the early days, the foxes were imported both for clothing and for profit. The first to arrive were black foxes in the late-sixteenth century when the Marquis de la Roche settled the island.

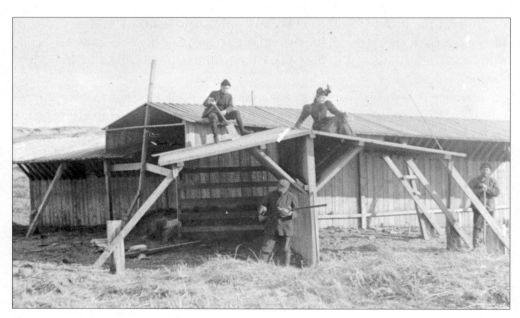

🦊 *At the pony stable before a fox hunt: Jim and Trixie are on the roof, Dick and Clarence are on the ground, 1900.*

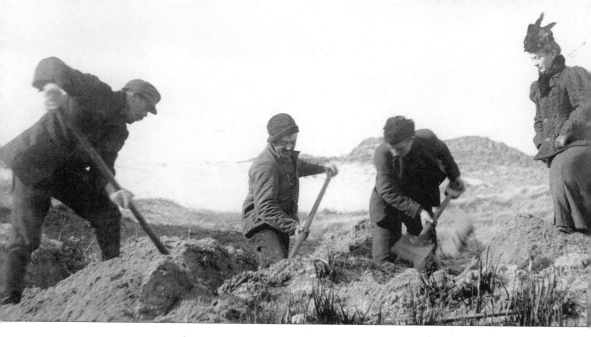

🐾 *Digging out fox burrows, 1900. L–R: Clarence, Dick, Jim, and Trixie.*

Exploited to extinction, the black foxes disappeared by the end of the American Revolution and before the beginning of the Humane Establishment in 1801.

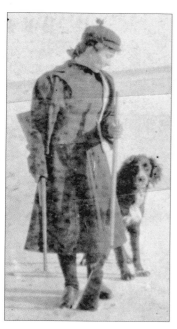

🐾 *Trixie and her dog, Cholo, on a hunting trip in 1904.*

In the 1890s, R. J. imported seven red foxes to kill the rabbits—another flawed import—which had overrun the island. Two years earlier in late February, he had tried to eliminate the rabbit population, which numbered well into the high hundreds.

The rabbits are more numerous than even I had any idea of and have forced the wild horses off miles of their choicest winter pasture, having eaten up every blade of grass old and new, and am convinced very active measures are necessary to prevent them ruining the Island. It must have been the rats prevented them increasing in any extent when on the Island before. I will ask for 30 cats—these will kill the young ones. I have a dog who kills about 100 each week and am training two more.

Even with the dogs and the staff digging out countless burrows, the rabbits persisted, hence the apparent need for foxes. In hindsight, it became obvious that bringing any animal into a closed

≈ *Jim, Dick, and Clarence hunting ducks and digging for clams, 1896.*

ecosystem such as Sable Island would only result in disastrous consequences. After the rabbits were controlled, the imported red foxes dined handsomely on domesticated chickens, ducks, and geese. On R. J.'s order, they had to go, but getting rid of them proved to be very challenging.

Very wily creatures, the foxes burrowed deep into the dunes. In order to kill them, islanders had to shovel out the dens and expose the vixens. Hunters, standing atop the dunes, shot them when they tried to escape. Some years, when the fox hunt was successful, R. J. sent more than one hundred pelts to Halifax where they sold for top dollar.

Not all the furs were sold to furriers in Halifax; however, everyone on the island had at least one piece of clothing fashioned from the pelts: mufflers, coat

≈ *Jim and Dick Bouteillier after a successful eel hunt, 1909.*

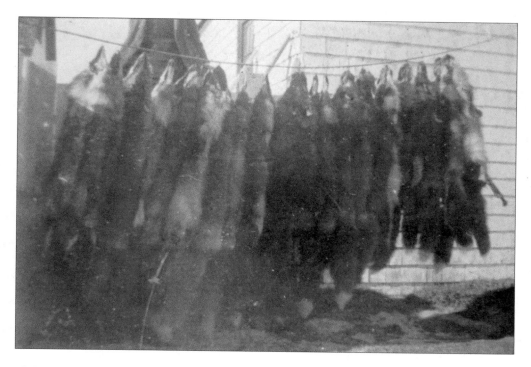

☜ Fox pelts strung up at the Main Station in 1896, ready for shipment to Halifax.

collars, slippers, hats, or scarves. The guard hairs on scarves kept the snow and sleet from collecting on the face, which was very welcome in a January snowstorm.

By age nine, Trixie's younger brothers, Dick and Jim, knew how to handle a shotgun. Always on the lookout for variation in their diet, the boys often brought home ducks strung on a line. Wild ducks, especially the migratory black ducks, made excellent stew. They knew exactly where to find the ducks in the tall grass along the margins of the lake and ponds. Trixie was a crack shot and would often join her brothers and visitors on the hunt. Wearing her hunting costume and walking with her dog, Cholo, she accompanied the men confident that she would bring home at least one trophy.

The Bouteillier children also had a great deal of fun spearing eels with homemade harpoons. The eel larvae found their way into Lake Wallace during their migration north from the warm waters off Bermuda. In time, they entered the freshwater ponds where they grew to maturity. Caught in large nets in the shallow freshwater ponds, eels were a delicacy for the islanders: they baked them into pies, or fried and served them with homemade pickles.

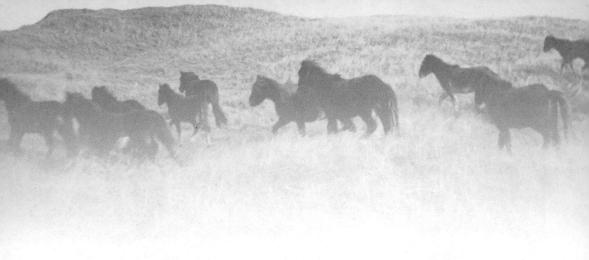

FARMING

At any given point on Sable Island, there were seventy-five to one hundred cattle, oxen, and pigs to feed and care for in addition to the hundreds of chickens, ducks, and geese that ranged free from the large chicken coop behind the Main Station and those at the rescue stations and the two lighthouses. These feather dusters provided fresh eggs for baking and roast fowl for evening meals. From feeding to butchering to cleaning and cooking, a Sunday dinner of roast chicken entailed a lot of work. Islanders had little time to daydream.

Large animals kept residents very busy: In May 1892, every bovine over the age of two had to be dehorned as they had contracted foot distemper. Slaughtering large animals like oxen, cattle, or pigs was challenging, but fresh beef, sausage, and salt pork were essential components of the islanders' diet. A large pig would net many pounds of salt pork, smoked ham, and long links of sausage. As the weather became wintry, residents needed to stock the larders in preparation for the approaching storms. Long, work-filled days hastened the changing seasons.

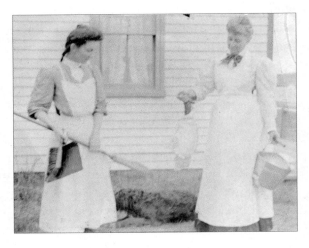

🖎 *Trixie and her Aunt Jane catching supper, 1909.*

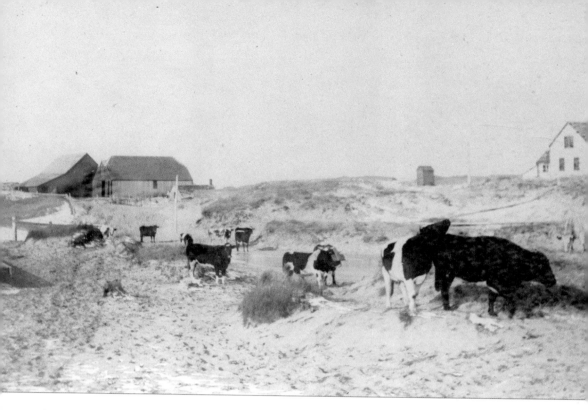

🖋 *Cattle on the path to the Main Station barn, 1900.*

In late October 1892, an ox named Houlihan tipped the scale at 1,004 pounds. R. J. led the ox to the cement pad facing the bleeding trough. Standing about three metres from the animal, his son loaded the shotgun. He raised the gun and expertly measured the intersecting lines on the trajectory between the animal's ears and eyes. He steadied his arm and pulled the trigger in one smooth motion. The animal dropped to the ground. It took four men to bleed, skin, and raise the carcass. Everyone anticipated slaughter day because of the fresh meat.

Hay grew abundantly in the valley between the two ridges of dunes, running parallel to the north and south beaches. To harvest hundreds of bales of timothy, residents used a mower and hayrick, which was much more efficient than old-fashioned hand scythes. Haying was a community event. Day after day, the hayrick was piled high and the waiting oxen would pull the heavy load to the barns; everyone knew that a good crop of hay was critical both to feed the domestic cattle and keep the wild ponies from starvation's door during the desperately cold winters.

The weather on Sable Island was always unpredictable, and sometimes residents had to drop everything to save their crops. R. J. wrote about one such rescue mission in December 1895:

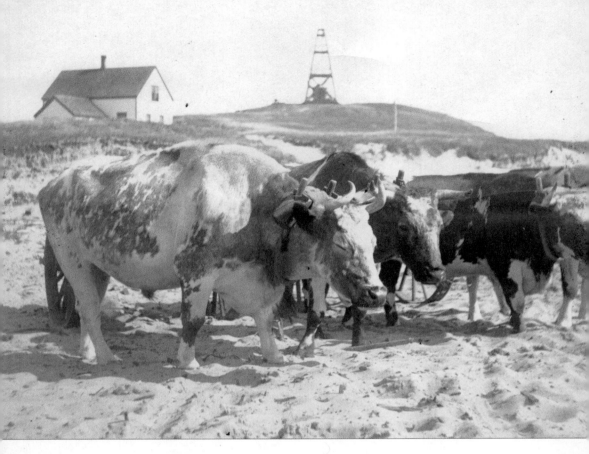

🐚 *Oxen were used for hauling heavy loads. These ones are resting near the Main Station, 1900.*

December of 1895 in a very high tide along with winds to 70 mph and sheet-ing hail, all hands were called out to save the hay. The next day, they found the whole north side awash at daylight. The hay had washed into the gulch or gone adrift. The staff had saved about 420 wet bales and 100 dry bales.

Everything on the island was used or recycled in some capacity. The eelgrass that grew along the ponds and Lake Wallace was harvested to use as insulation against the snowstorms that ravaged the island in January and February.

On November 30, 1905, R. J. wrote, "Banked the stable, hospital and sailors' home with eel grass." This traditional insulation is still used in some rural areas across the Maritimes.

Caring for farm equipment and buildings was a constant job. Carpenters had to keep up with shingles blown off during storms and repair damage from frequent lightning strikes. One year, lightning incapacitated both the barn and

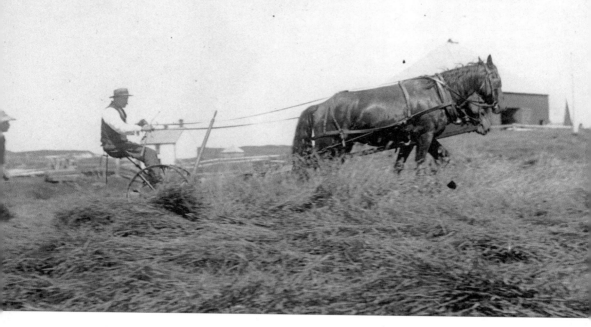

꒰ *An unidentified staff member cutting timothy near the Main Station, 1898.*

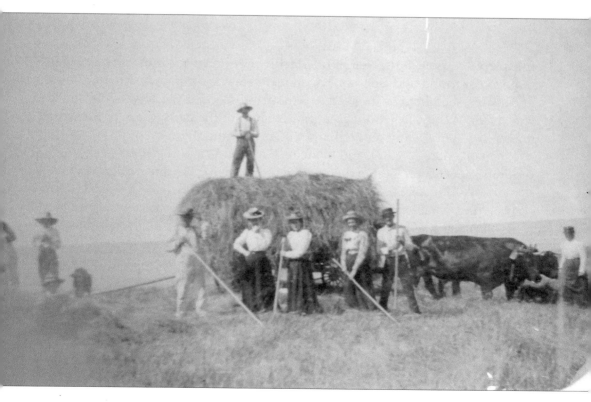

꒰ *Everyone helped with the back-breaking work of haying, 1898.*

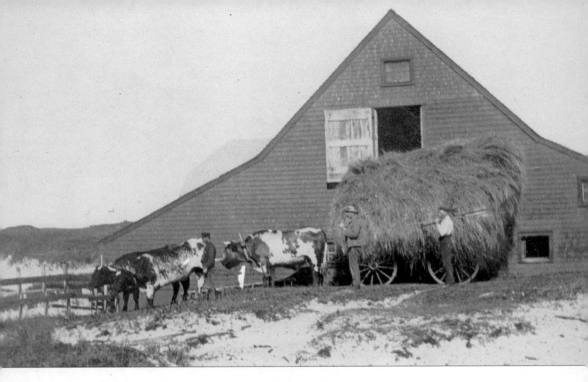

Hay wagon with a heavy load for the Main Station barn, 1898.

the telephone pole at the east light. Machinery and telephones had to be maintained year round and wooden wagons often needed repair. Leather harnesses and strops needed to be greased to remain supple, and truck wheels often lost rim rivets. Wisely, R. J. built a carpenter shop in the early years of his tenure to help his staff fix any of the many things needing fixing.

On one occasion, R. J. and his wife, Ellen, had been at station #4 setting up the brand new telephone. On their return the following day, an accident occurred:

> *Mrs. B and I started from #4 at noon and drove 2 miles when accidentally upset throwing us both out, dislocating Mrs. B's wrist and inflicting a small deep wound above the right wrist. Walked back to #4, as the horses ran away and made kindling wood of the trap. After setting Mrs. B's wrist, started for #1 in #4's buckboard.*

꿎 ꛤ

Mr. Egan, primary carpenter at the Main Station, was pleased to work under a man of R. J.'s caliber. There was never a wood-related problem R. J. could not solve. From masts to fencing, to towers and root cellars, to re-planking floors,

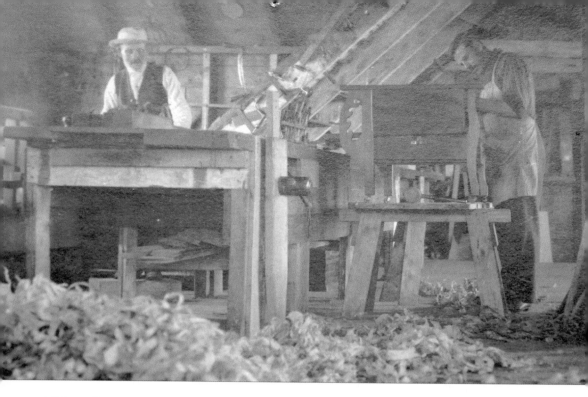

Johnny Dunn (L), with carpenter Mr. Egan at the Main Station wood shop, 1900.

Superintendent Bouteillier offered his expertise. The floor of the carpentry workshop at the Main Station often ballooned with his scented planing scrolls.

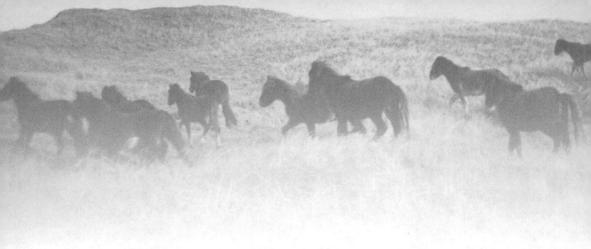

THE CRANBERRY HARVEST

Cranberries were one of Sable Island's cash crops. Each fall, all of the islanders took part in the harvest. Using rakes and stiff brooms, men walked in lines beating the lowbush plants to release the tart, crimson berries. Women and children walked behind to collect the berries in large baskets. It was back-breaking work.

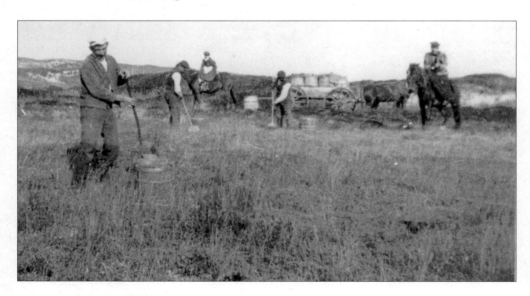

Harvesting cranberries in the Barrens Valley, mid-island, 1897.

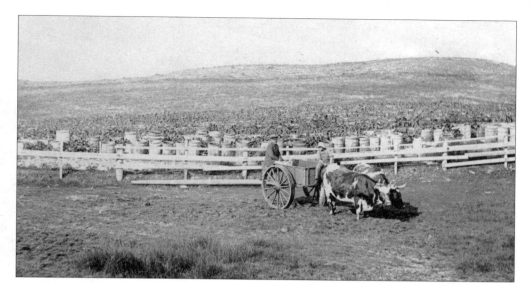

⛊ *Workers load oxen-drawn carts with barrels of cranberries to ship to the mainland, 1897.*

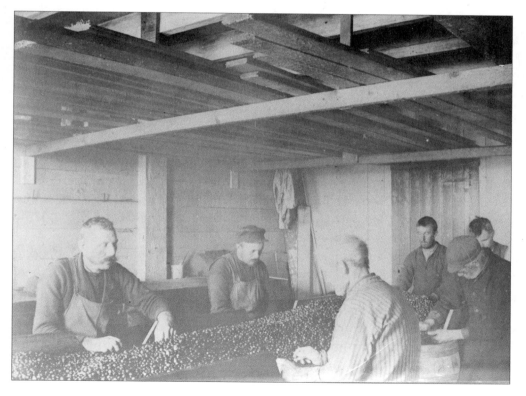

⛊ *Sorting cranberries by hand at the Main Station, 1897.*

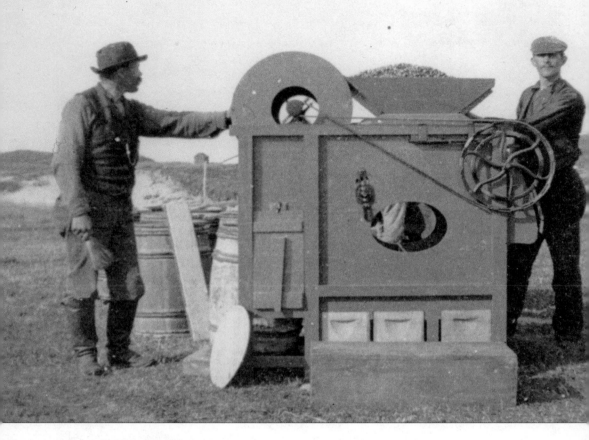

🐚 *The mechanical cranberry sorter sped up the harvest significantly.*

Near the cranberry bog, a wagon loaded with empty flour barrels waited to load the berries. Before the mechanical separator arrived in 1899, berries were sorted and cleaned by hand. Back at the barn, the men dumped the berries into a long trough-like table with little doors in it. The good ones rolled through the doors into the barrels, and the bad ones were thrown out.

Every year, the superintendent recorded the number of barrels shipped to the mainland. In 1894 for example, 225 barrels were shipped, but in 1896, there were only 63. In 1905, a record 305 barrels of cranberries were shipped. Some years the berries were small and of poorer quality, but most years they were lush and plump, number-one berries, and sold for five dollars a barrel. The quality of the crop relied on rain in late July, and warm temperatures in August and September.

In the kitchens at each station, fresh cranberry bread and cranberry jelly filled the larders. For years, visiting government officials such as Mr. Cribb, inspector of lights, or representatives of Department of Transportation and

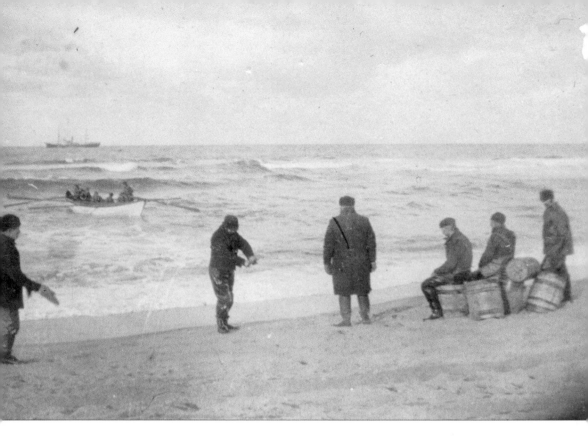

⚓ Workers wait on the beach for the surfboat to arrive and take barrels of cranberries to the supply ship anchored in the distance, 1897.

Marine and Fisheries raved about Miss Trixie's Sable Island cranberry jelly. In a banner year for the harvest, she bottled up forty-seven jars of the sweet condiment. She never divulged the recipe, but she always gave countless jars of it away.

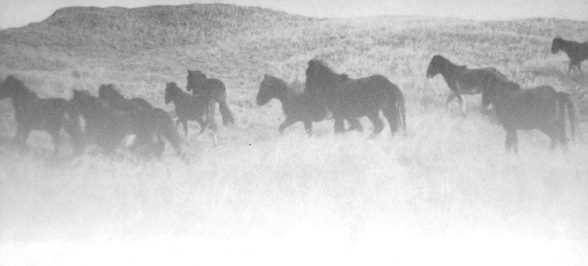

WIRELESS
COMMUNICATION

I n May 1904, the Canadian government signed a contract with the Marconi
Telegraph Company to build thirteen wireless stations along the Gulf of St.
Lawrence and the eastern coastline. Acting with unprecedented speed for
a bureaucracy, six stations were constructed in 1904. Fame Point (Pointe-à-la-
Renommée) along the Gaspé Peninsula was the first.

Led by John D. Taylor, the OIC (Officer in Charge) of the wireless station con-
struction crew, the 1905 season began in May with the erection of Camperdown
outside Halifax. Sable Island was next in line.

There was great urgency to build the wireless station on Sable Island.
Wireless technology on ships and in coastal stations was saving lives of ship-
wreck victims everywhere it was installed, and the Graveyard of the Atlantic
was a high priority. The crew finished up in Halifax, had a two-day rest, and
then boarded the government ship *Lady Laurier* to Sable Island.

J. D. Taylor and his men were well trained and experienced, but they would
need every bit of their talent on the shifting isle of sand. They couldn't predict
what monkey wrench she might throw into the mix. Work began at 5:00 A.M. and
ended at sunset. By June 5, 1905, teams of oxen had hauled all material for the
station from the beach to the site. The transmitter hut was raised on June 14, and
the engine room completed shortly thereafter.

However, it was not constructing the buildings that posed the greatest
challenge for the crew; it was raising the masts and the aerial. In the course
of construction, one of the workers drove a nail through his foot. Twice, carts

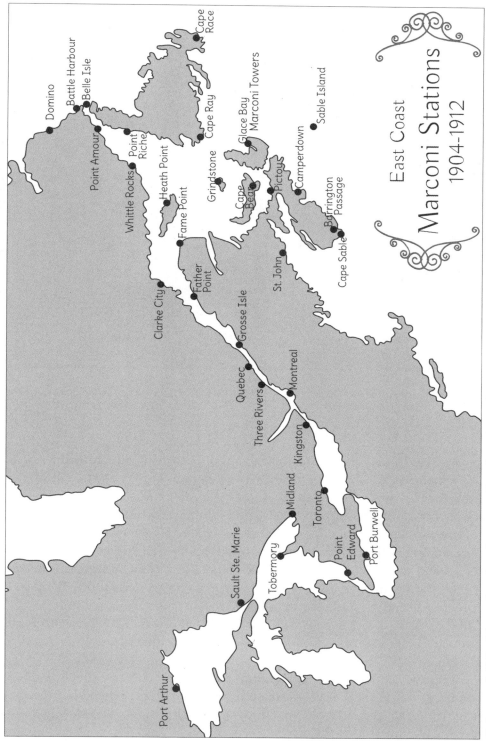

East Coast
Marconi Stations
1904-1912

Cape Race
Battle Harbour
Belle Isle
Domino
Point Amour
Point Riche
Cape Ray
Glace Bay
Marconi Towers
Sable Island
Whittle Rocks
Heath Point
Grindstone
Camperdown
Cape Bear
Fame Point
Pictou
Barrington Passage
Clarke City
Father Point
Grosse Isle
St. John
Cape Sable
Quebec
Montreal
Three Rivers
Kingston
Midland
Toronto
Sault Ste. Marie
Tobermory
Point Edward
Port Burwell
Port Arthur

꩜ *A map of all the Marconi stations in eastern Canada as drawn by Lisa Wright. (Based on original from the National Archives, 1920).*

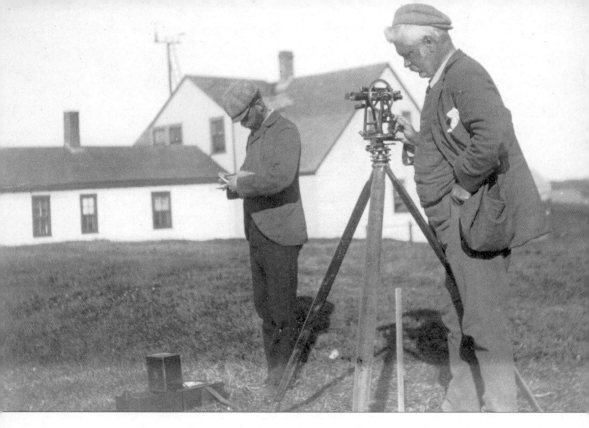

❧ Colonel William Anderson (R) and his assistant, Mr. Murphy, survey Sable Island, 1901.

overturned and threw the occupants and supplies to the sand. The trained wild horses sometimes had minds of their own and would swerve left when the driver called right. The night before the topmasts were to be raised, the shear legs—which anchored the first eighteen-metre pole—toppled in hurricane-force winds.

Three weeks later, having overcome all obstacles, the transmitter hut, including living quarters for the operators and the fifty-five-metre mast, was complete. Several months later, R. J. insisted a metallic circuit be strung between the Main Station and the wireless hut in case of emergencies. Both Trixie and Jim practiced sending and receiving messages on this subsidiary line.

In those early years, the call sign for Sable Island was "SD." Once those call letters were assigned, operators and residents alike affectionately referred to their island as "SD" both in their correspondence and in conversation.

Everyone stood anxiously around the senior wireless operator, L. R. Johnstone. It was 7:30 P.M. on a warm summer evening. He tapped out the first message from Sable Island and sent it into the ether. It was received shortly thereafter in the Halifax station at Camperdown, call sign "HX." When First Operator

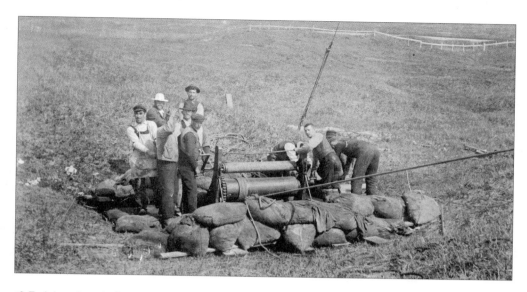

🖎 *Raising the wireless pole in 1905. L–R: J. D. Taylor, R. J. Bouteillier, unidentified construction crew members, Clarence Bouteillier on the right facing the camera.*

James Barridon received it, he sent it on by land telegraph to some very important people: Prime Minister Wilfrid Laurier, Dr. Alexander Graham Bell, Colonel Francois Gourdeau, Dr. J. Dwight, and R. J.'s mother in Halifax who was more than pleased to receive the "Marconigram" from her son, which read:

> *Canada's southeast outpost long isolated now joined by Marconi wireless. Congratulations on success of completed station.*

R. J. Bouteillier, Supt. Sable Island.

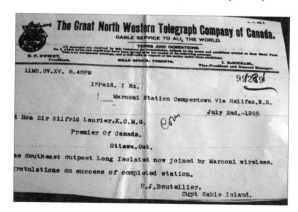

🖎 *A copy of the telegram Superintendent R. J. Bouteillier sent Prime Minister Wilfrid Laurier in July 1905.*

Sable Island had cut its wireless teeth. Many of these early wireless men played important roles in the development of the new technology known as radio. Donald Manson, a young lad of eighteen, came to Sable Island from Scotland. He worked with the Marconi Telegraph Company for many years at the transatlantic station at Glace Bay, at stations along the Great Lakes, and at the company's head office in

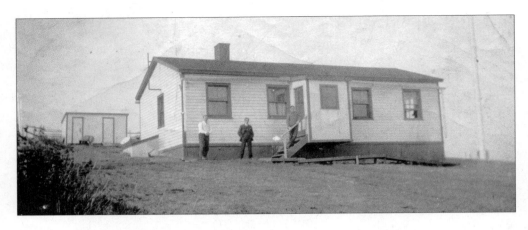

⌇ The Sable Island wireless hut, June 1905.

Montreal. Manson was instrumental in drafting practically all radio legislation in Canada during the pioneering years, and retired in 1952 as general manager of the Canadian Broadcasting Corporation (CBC).

R. J.'s youngest son, Jim Bouteillier, joined the Marconi Telegraph Company in 1907 and served as operator on Sable Island for several years before he moved on to the Magdalen Islands. When the First World War began, the Marconi Company lent some of its experienced wireless operators to the Royal Navy. Jim spent the rest of the war as Warrant Officer First Class working at the Mount

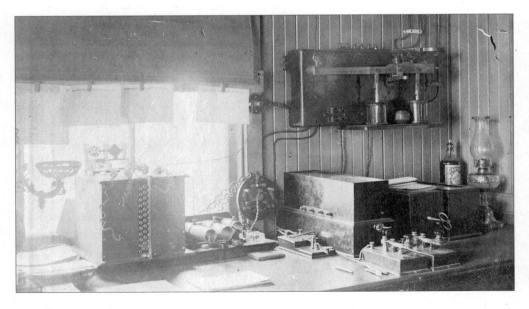

⌇ Inside the wireless hut—note the bottle of rum on the far right.

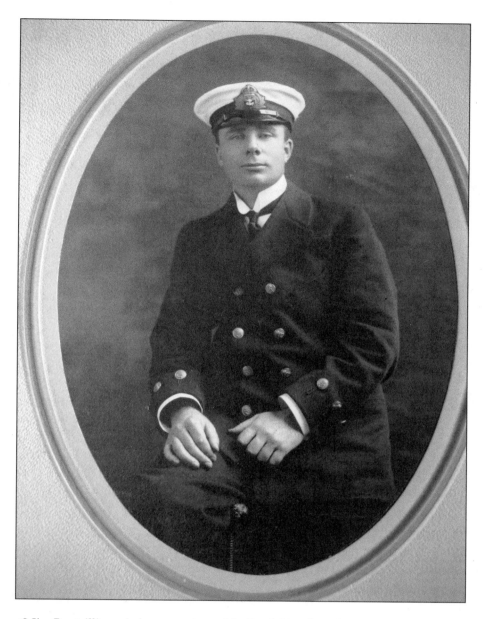

⇨ Jim Bouteillier, wireless operator at Mt. Pearl, Newfoundland, which was a high-powered station during the Second World War.

Pearl wireless station outside of St. John's, Newfoundland. He remained ashore protecting the far eastern coast of North America from attack by sea. Years later when Jim would talk about his stint in the navy, he liked to say "wireless silently saved many lives one tap at a time."

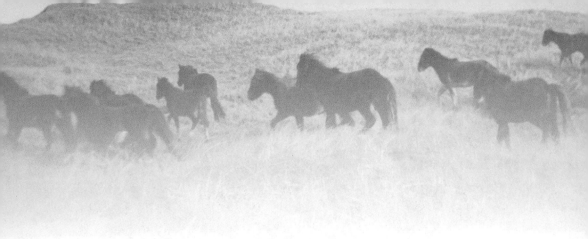

METEOROLOGY

The Sable Island Main Station could be considered one of the first weather stations on the east coast of Canada.

In 1890, Augustus Allison arrived on the island to set up the Main Station meteorological station. The Department of Marine and Fisheries installed an anemometer, wind vane, and an anemograph; invaluable tools to accurately record the speed and direction of the wind, which was necessary to track incoming storms. The telephone made weather reporting more accurate. R. J. received

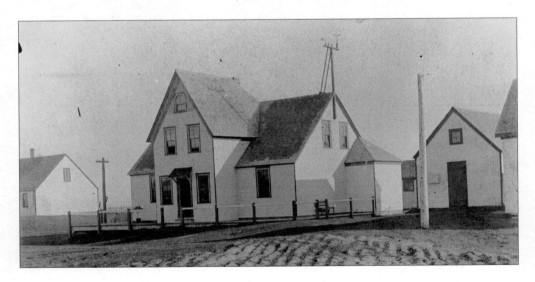

The meteorological equipment high atop the Main Station roof, 1900.

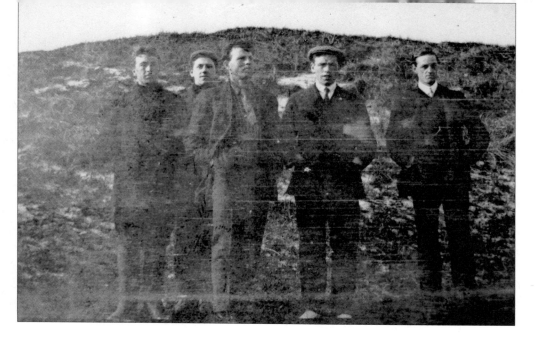

🐚 *Wireless operators in 1909. Third from the left is L. W. Stephenson, and on the far right is J. D. Taylor.*

telephone weather reports from each lighthouse and lifesaving station on the island twice daily. He recorded wind speeds and ambient weather conditions. This way, he always knew what was heading Sable Island's way.

Initially, the equipment was mounted on the staff of the Main Station, and then moved to the roof. Later, they were attached to a platform at the top of a 4.5-metre ladder high above the gable peak. It was certainly not a job for the faint of heart. In one of his journals, R. J. notes that his meticulous weather records were used as evidence during the 1906 inquiry into the foundering of the *Rembrandt*. R. J.'s records proved that weather played a huge role in the disaster. During a November gale in 1905, while being towed, the *Rembrandt* lost her hawser in heavy seas. All aboard were lost. The inquiry board deemed both the captain of the tug and the captain of the *Rembrandt* at fault.

After the wireless station was installed on Sable Island, the Department of Marine and Fisheries thought it would be useful for ships to receive weather forecasts in addition to the 10:00 A.M. time signal from wireless stations at Halifax, Amherst, and Sable Island. Weather reports provided ships' crews with one more navigation tool.

ENTERTAINMENT AND LEISURE

I t was not all work and no play on the sand spit. There were many opportunities when staff members were, as they called it, "on liberty."

Since the wireless men were stationed on Sable Island for months at a time, they were bound only by their imaginations to fill their downtime. Young Harry Pearson had a flair for humorous art, Alexander Reoch added his deep baritone voice to the Marconi Trio at the spring concert of 1907, and Gilbert W. Blackburn enjoyed invigorating horseback rides to the west bar.

Every Sunday, the wireless men attended services at the Main Station and often had dinner together in the evening. The path through the grass from the Main Station to the wireless station was very well worn.

All the Bouteillier boys learned how to sail. After all, they had a lake out their back door and many boats at their disposal. They sailed and rafted on Lake Wallace, which, in those early days, was almost twenty kilometres long. When a fine breeze was blowing, a small

LOCAL NEWS

Last Sunday Mr. Gray arrayed himself in his glad rags and attended Church.

⚓ *Harry Pearson's caricature of fellow wireless operator Walter Gray, drawn in 1905.*

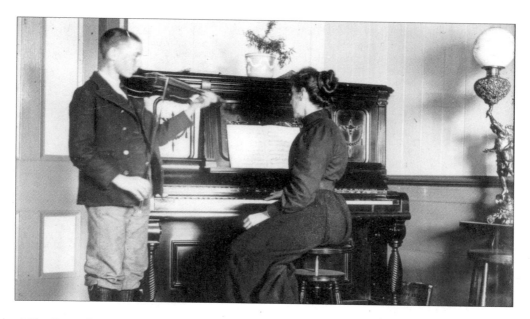

≈ *Jim Bouteillier during a violin lesson in the Main Station's "Blue Room", 1896.*

Commence Carriages
7 pm Sharp 8-30 pm

(1) Overture Professor Jack (7) Sketch
 "The Country Curate"
 By
 Reevo

(2) Song (8) Song
 "Following in Fathers Footsteps"
 By By
 G. P. Reeves J. Glazebrook

(3) Song (9) Grand Cock Fight
 By The
 By Sable Island Cocks
 Mons de Glazebrook Bertrand and Theopolis

(4) Greco-Roman Wrestling (10) Duet
 Between "Wearing my heart away for you"
"The Newfoundland Tiger & The Sable Island Lion" By
Best two pin falls out of three Antigonish & Worcester
 Referee Mons de Glazebrook
 Time keeper Professor Harris (11) Child of 3 Impersonation
 "Mary had a little lamb"
(5) Song By
 "The Parrot said come in" Professor Reeves
 by
 Professor John Dunn (12) Song
 "The girl I left behind me"
(6) Song By
 "The Blind Boy" John Dunn
 By the
 Marconi Trio God Save the King.

≈ *The program for the 1907 spring musicale put on by Sable Island staff.*

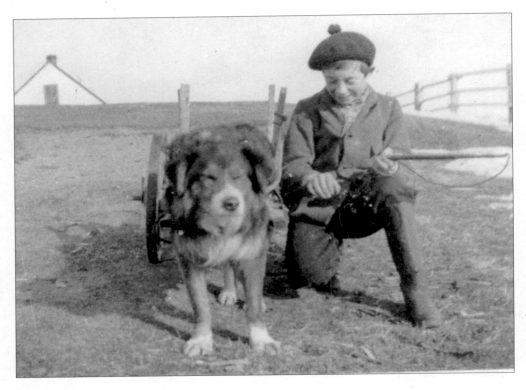

Jim Bouteillier with his dog, Spud, rigged to a homemade cart, 1894.

ketch could skim down the lake in no time and the boys could visit with friends at the mid-island stations, or deliver invitations for the semi-annual musicale.

On warm summer afternoons, island residents slowed their pace. They would go for a swim or set out in a dory or jollyboat, fishing trawl in tow, for fresh cod or haddock. Sometimes young Jim would harness the Bouteillier family's pet dog, Spud, into the traces of a homemade dogcart.

Other residents would simply bask in the island's temperate climate in the lee of a dune, or pick a pail or two of gull eggs. On sultry summer days, when she had a few hours of leisure time, Trixie loved to wander, snapping photographs that captured the essence of life on the island.

Occasionally, pleasure yachts or schooners sidled close to Sable's north beach, and in 1891, on a delightfully calm sea, a smart yacht called *Ontario* dropped anchor for an afternoon. R. J. and family served tea and cookies to the visitors before they rowed back in their dingy to their ship and sailed on with the high tide to Halifax.

At the end of a long day, many island residents enjoyed walking along the beach. Often these walks offered much more than just beautiful scenery:

⚬ *Clarke Bouteillier sailing the* Trixie *down Lake Wallace, 1896.*

⚬ *L–R: Maggie Bouteillier, Cyril Mitchell, R. J. Bouteillier, unidentified, and Johnny Dunn, swimming in Lake Wallace, 1901.*

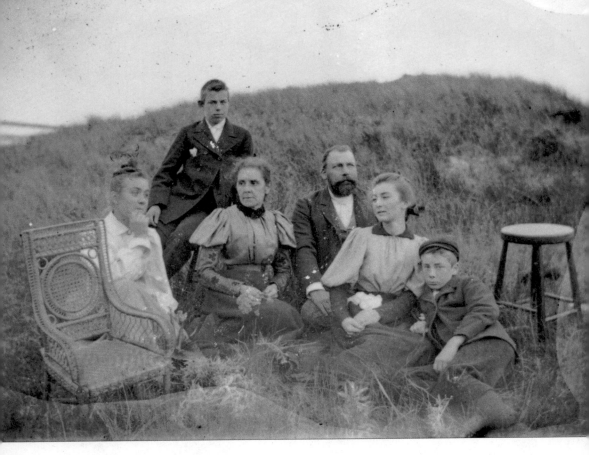

🖎 *The Bouteillier family enjoying a summer picnic on the dunes in 1899. L–R: Bertha, Dick, Maggie, R. J., Trixie, and Jim.*

messages in bottles were common discoveries. R. J. remembered one message in particular: "May 17. Mafeking relieved. Roberts in the Transvaal." The bottle was resting in his path and R. J. thought it might have been dropped overboard from a troop ship returning from the South African War. The message was obviously from a soldier or a news correspondent returning home from the battlefield. Carried on the currents, the news of a battle in Africa had washed up on his tiny island, thousands of kilometres from the fighting.

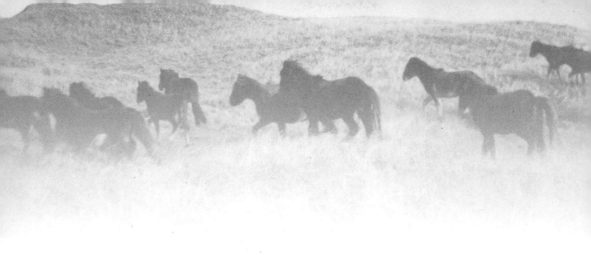

SABLE ISLAND HORSES

S able Island horses are recognized worldwide; their long thick manes and flowing tails are reminiscent of the horses of antiquity. There are many theories about how they arrived on the windswept island: perhaps they were stranded following a shipwreck, or left to roam the dunes following the expulsion of the Acadians. Maybe they were brought to Sable Island as part of a colonizing expedition. Regardless, the horses have survived and flourished.

R. J. kept detailed records of the horses on Sable Island: those injured, destroyed, tamed for work, or sent off the island. He called it his "horse census." It

🐾 *Wild horses grazing near the mid-island ponds, 1900.*

🐎 *L–R: Gilbert Blackburn, John D. Taylor, and Trixie out for a ride on the beach, accompanied by Cholo.*

was important to keep only as many wild ponies as the island could sustain, because if the numbers grew too large there would not be enough food to go around. By the same token, horse gangs could not have two dominant stallions; fights between them could result in severe injuries or even death. R. J. nearly lost his favourite horse, Sable Prince, to a rival stallion when he returned to his gang.

Sable Island horses are stocky and strong and range in colour from almost black to bays of dark chestnut and a warm golden taffy. In 1894, however, a white foal was born—an anomaly indeed. Naturally, he was given the name Snowball, and was the only white pony to live in the stable at the Main Station.

On several occasions, R. J. imported Arabian stallions—some from Alberta, others from Belgium—to improve the stock of the island herd. One horse, Pretoria, did not adjust well to island life. He broke out of the stable, destroyed a carriage, and attacked residents. Eventually, he had to be put down.

Every station had at least two or three tamed horses for staff use, while the Main Station and lighthouses stabled many horses for emergency situations. R. J. had a particular system for naming these horses: those born in the stable from tamed stock were named for shipwrecks, visitors, coat colour, or a child's choice.

Most children learned to ride before age eight, as it was an essential life skill on the island. Trixie was a fine rider by eight, and by age ten she could drive

Snowball, the only white Sable Island pony, at the Main Station barn with Clarence Bouteillier, 1897.

a trap with confidence. She was most proud to say that she always rode side-saddle as that was considered the ladylike way to ride. Dressed in boots, jacket, long skirt, jaunty hat, and leather gloves, Trixie's rode her horse, Midge, who responded to the soft touch of her small leather whip. In 1984, Trixie's original sidesaddle was donated to the Museum of Natural History in Halifax.

Twice a year, R. J. shipped wild horses to Halifax for auction. The proceeds of these sales were used to offset the cost of running the lifesaving stations of the humane establishment. Horse corrals were built near the beach. Teams of workers herded the horses into the enclosure where select mares were chosen for auction. It was a dangerous job: broken legs and arms were common as horses often tried to kick workers in the face. Despite R. J.'s care, one young man lost an eye when a horse reared in protest.

Following the wild pony roundup, a few horses were selected to be tamed. At any given time, there were between twenty-five and thirty workhorses on the island. On Sable Island, five horsepower was meant literally—five horses pull-ing a cart, wagon, or trap. Using horses made plowing, planting, and harvesting hay and other crops much faster, and residents could quickly move lifeboats to a shipwreck if need be. Once a wrecked crew was safely ashore, the horses could remove salvage from the derelict ship.

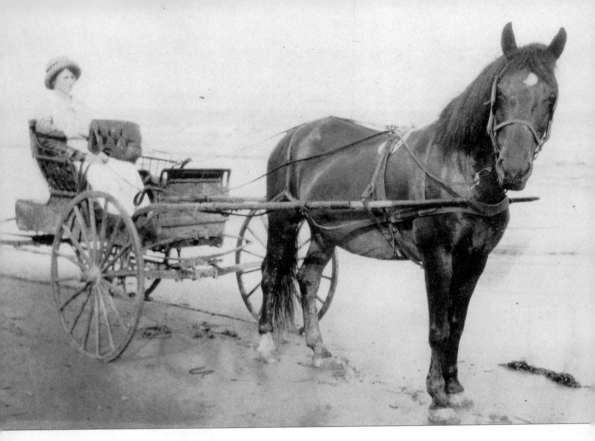

Trixie driving the one-horse trap, pulled by Nibs, 1900.

For years, R. J. and his men used five-horsepower teams to haul lumber, coal, kerosene, diesel fuel, and other necessities from shipwrecks like the *Crofton Hall* (1898) and the *Skidby* (1905). Although they were stuck fast in the sand and mast-less, these two ships were easily accessible and remained structurally sound for years.

Veterinary care also fell to the superintendent. When several horses suffered colic, R. J. dosed them with bicarbonate of soda, laudanum, and terps. The cure usually worked, but if not, a bullet to the head eased their suffering.

Sable Island horses were not shod, so their hooves were unprotected. In a way, this was better as there was no chance of sand getting under the shoe and causing irritation. But the horses still suffered injury, the most common ailment being a broken foreleg. When a horse became lame, R. J. would attempt to splint the break, but often the horse had to be put down.

R. J. had a strict stance on pets: living on Sable Island meant islanders had to butcher, kill, or shoot any number of animals; if children became too attached to a rabbit or a horse, it usually meant grief later. Young Trixie, however, rescued

The pony containment corral for the wild horses caught in the roundup, 1897.

Lassoing a Sable Island pony before transporting it to the supply ship for auction in Halifax, 1899.

🐎 *Ten-year-old Jim Bouteillier atop Topaze, 1895.*

an orphaned foal that her father believed would never survive, and planned to shoot after its mother died giving birth. Ostracized by its gang, the foal was left to forage for itself. Despite Trixie's many attempts to obey her father and ignore

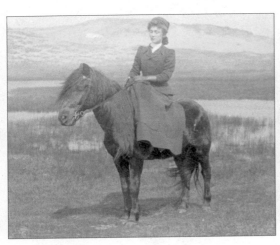

🐎 *Trixie (Sable Island Princess) sidesaddle atop Midge, 1899.*

🐎 *Trixie and Bertha in their riding out-fits, 1899.*

The horse auction in Halifax, 1902. Trixie's pet, Bonnibell, is on the far left.

the little horse, it kept returning to the Main Station. In time, it came to Trixie's call and ate out of her hand. She named her Bonnibell. Two years later, when the horse was shipped to Halifax for auction, Trixie tied a sign around her neck, which read, "Her name is Bonnibell, Trixie's pet. Be good to her."

Of course, horses were also used for pleasure. Visitors loved to ride the tamed wild horses. Accompanied by Trixie's dog, Cholo, groups of riders toured the island from the saddle of a Sable Island pony. Special requests from the mainland for tamed island horses were not uncommon, and in November 1901, R. J. even shipped a horse to Lord Minto, the governor general of Canada.

DECEMBER ON SABLE ISLAND

In December, shortened daylight hours meant two things for Sable Island residents: stay inside and delight in the warmth of family, but always remain alert for ships lost on the bar.

Each year, gaily dressed Christmas trees brought great joy to the island's children. In the Bouteillier household, the family settled in the "Blue Room" while the wind whistled through the gables. Trixie played the piano, Jim the violin. When the sun dropped out of the sky at 4:00 P.M., Trixie buried herself in books. When the ponds froze, children replaced their boots with skates and their happy shrieks echoed between the dunes.

For luckless ships that crept too close to Sable Island, though, December often spelled tragedy.

In December 1884, just three weeks after he had been appointed superintendent, the fishing schooner *A. S. H.* from Saint-Pierre and Miquelon struck the

◁ *Trixie showing off the 1902 Christmas tree with all the homemade gifts and candy.*

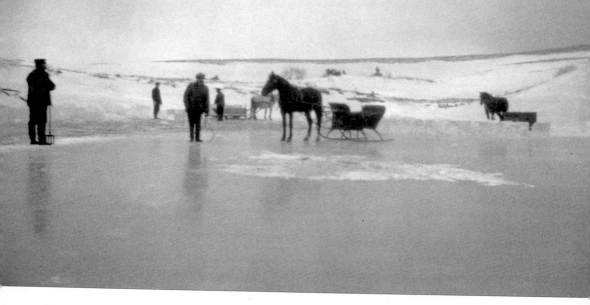

⅋ *When Lake Wallace froze over, it was perfect for skating and sleigh riding, 1902.*

northwest bar. It was late at night, and in the middle of a ferocious snowstorm. With appalling clarity, Superintendent Bouteillier recalled the storm that lashed the island that December. It was a gruesome affair: one man saved, three lost. In the log for December 20, 1884, were the horrible details.

> *The Brigantine A. S. H. from St Pierre and Miquelon had foundered on the Lake's northern Shore. The wreck was located by the Superintendent on the way up to the lighthouse and a messenger sent back to direct the entire main station staff to scour the beach at daylight. The storm wind was so severe that one of the bodies had to be chopped out of the ice into which it was firmly frozen. The other two bodies were both barefooted and sparsely clad.*

Hung up on the sandbar in the freezing cold and gale-force winds, the men had no choice but to launch their dory and try for shore. Their boat overturned in the surf, but the crew, three sailors, and the captain made it to shore. They could see the west light, which was eight kilometres away from the Main Station. They started for it.

They climbed up over the north bank of the island. They were sopping wet, the wind was blowing, and the temperature was down around freezing. On the way, one man tired and begged the others to leave him. They tried to carry him, but couldn't. They went on. Soon another man fell, exhausted, to the sand. They had to leave him also. In the end, only one man got to the lighthouse. He had crawled for a good half kilometre.

DECEMBER ON SABLE ISLAND 105

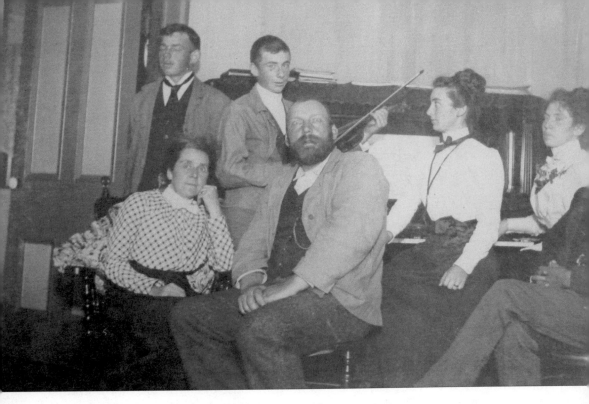

The Bouteillier family and staff gathered round the Blue Room piano at Christmastime, 1901. L–R: Dick, Maggie, Jim, R. J., Trixie, Miss Ancient, and Mr. Bennett.

William Merson, the west lighthouse keeper, slept fitfully through the storm, but it was his wife who woke up. She had heard a noise outside that sounded like a young seal crying for its mother. Finally, the man managed to knock on the door. They brought him in and warmed him up. He kept repeating, *"capitaine, capitaine…Himmy."* He couldn't speak a word of English, but he kept holding up four fingers: a captain and three men. But there was no telephone then.

Despite the dangerous wind, heavy snow, and sleet, Merson saddled his horse and rode the eight kilometres to R. J. and the Main Station. Two hours later he arrived at the Main Station, his hands and feet almost frozen and his pants stiff as a board. His horse could barely stand.

R. J. ordered his lifesaving crew to prepare the *Reliance* for a rescue mission at dawn, gave Merson dry clothes, saddled a fresh horse, and he and Merson rode from the Main Station to search for the wreck. As they headed west, they heard a dog barking. No more than half a kilometre from the station, R. J. saw a black dog running along the bank. Thinking it was his family dog, Cholo, he told her to stay home. The dog turned away from him and the two men rode on.

Early the next morning, R. J. and Merson searched the beach. They found the empty dory, but no men. In such a storm, no one thought the men had made

Dec 19 Wind N. Blowing Gale. Blinding Snow Storm.
Cattle would not leave the Barn.

Dec 20th. Wind N. N.E. Storm stile violent.
Wreck reported at 1.30 a.m. by Mr. Merson
from the West End Light. A fearful night
to venture out in. A shipwrecked sailor
came to his door at 11.40 friday night;
exhausted, one foot bare, nearly gone.
A Frenchman, could only say Ship. seven.
The Superintendent with three men set out
immediately. Reached the West End Light,
at 4 a.m. Sailor could not speak English. had
two mates Certificates. one signed Phillippy
the other Bodiguet. Superintendent left at
daylight. Wreck a Brigantine, found broken
up, on the shore near the Highlands, north
Side. On the way back found two dead
bodies: one on the cliff side; the other over

R. J.'s log recording the wreck of the SS A. S. H., December 1884.

it over the bank, but they did: they had walked inland on the opposite side of the island.

In daylight, they found the captain, perished. He was lying in a sand hollow half a kilometre from the Main Station with a big black Newfoundland dog curled up, still alive, beside him. Perhaps the dog had helped the men get to shore and, true to his breed, remained at his owner's side until the bitter end. R. J. was certain that all the sailors had survived the beaching and become separated in the aftermath. The captain appeared to have climbed up and over the bank, and then laid down, cold and exhausted, the dog with him. R. J. understood the brutal truth about seeing the dog the day before: it had not been obeying R. J.'s command; it had come searching for help, and returned to its captain to keep him warm.

They buried the captain in the graveyard on Monkey Puzzle Hill and for days, the dog, Himmy, wouldn't leave the grave. He almost starved to death.

◁ *The gold medal R. J. was awarded in 1885 for his lifesaving efforts after the wreck of the SS A. S. H.*

Finally, he came to the sailors' house, where the men would throw him something and he would eat, but for weeks he went back to the grave and pined.

Himmy stayed on Sable Island for the rest of his life, adopted by R. J.'s family. Every December, the loyal Newfoundland dog would lie by the grave of his former master, as if to honour the captain.

R. J. received a medal of honour from the Republic of France for his heroic efforts that frigid December night. The inscription praises Superintendent Bouteillier's courage and devotion in the face of great personal danger. For R. J., though, the act of offering succour and doing his duty to his fellow man was reward enough:

> *December 5, 1900 — Sixteen years ago today I landed to take charge of the island. Although many changes have occurred during that period I can find much to be grateful for and feel that I have been allowed a fair measure of success in my administration of affairs here.*

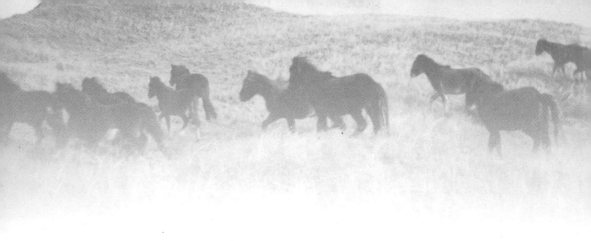

FIFTY YEARS LATER: SABLE ISLAND IN 1967

Insistent tentacles of sand creep through the windows of the Blue Room and threaten the second-floor attic rooms of the Bouteillier family home at the Old Main Station. Battered by fifty years of southwest gales from the Gulf, the walls of the home, a caricature of what they once were, lean drunkenly to the east. The paint has peeled, the floorboards have faded to slate grey, and the window frames sit vacant.

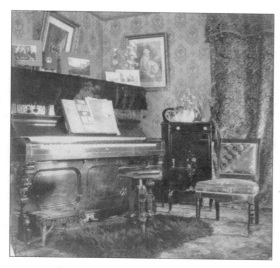

The Main Station's so-called "Blue Room."

For decades, Trixie had preserved her life on Sable Island in photographs and memories, but when she returned to the island in 1967, the present had wiped out the past as she knew it.

Sand had reclaimed the boathouse and barns. The garden was overgrown with marran grass, wild pease, and strawberries. The telephone poles her father had so adamantly requested stood like lonely sentinels in their track along the old path, the wires long gone. Lake Wallace had shrunk to a tenth of what it was when she lived there.

Lifesaving station #3 being reclaimed by sand, 1967.

Only the sand, the relentless surf, and the wild ponies were the same. They freely ranged about the ruins of the "Old Main Station" as the modern island dwellers called it.

Recent residents and visitors often muse about the people who lived on Sable Island so many years ago. What were they like? How did they survive without the radio, electricity, satellite communication, or air service to the mainland? Who planted the roses?

Well, if Trixie could speak, she would say it was a wonderful place to grow up. It was home and they just didn't know any different. And she would proudly smile and say that she, her mother, and her sister planted those roses.

Trixie Bouteillier, age eighty-seven, standing beside her Sable Island rose garden.

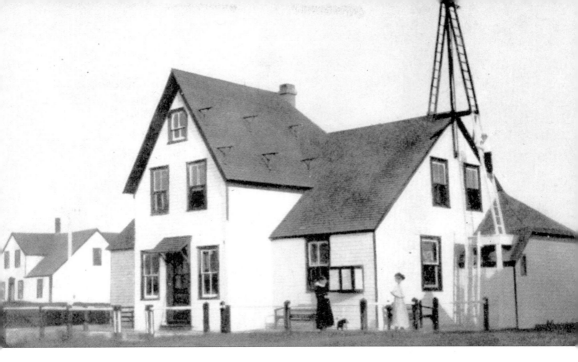

⛫ *The Main Station as a fine home, 1901.*

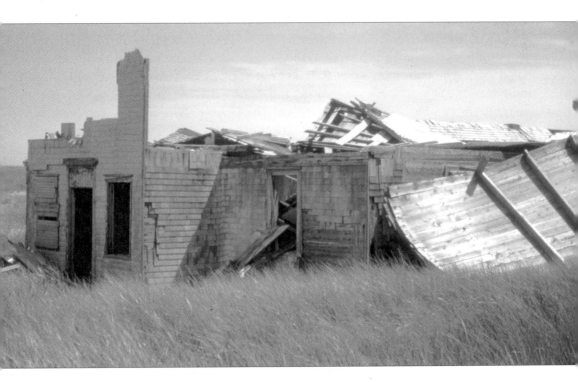

⛫ *The Main Station becoming a ruin, 1967.*

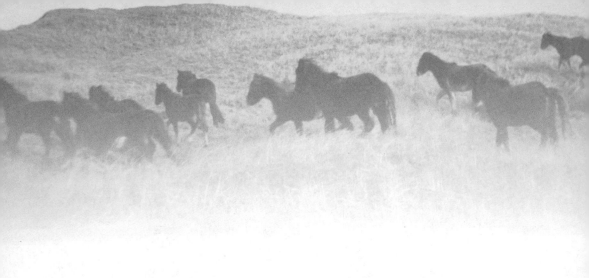

SABLE ISLAND TODAY

In 2013, the family of Canadian National Parks welcomed Sable Island as its newest member, and Parks Canada now serves as caretaker of the island on behalf of Canada and the rest of the world. Sable Island's human population has dropped considerably since R. J. and his family lived there. Five people currently call the island home year-round, but during the summer months, numbers rise into the double digits. Since 2007, a team of researchers from the University of Saskatchewan has returned for an annual seven-week stay as part of their ongoing study of the feral horses.

Four residents staff the Main Station year-round. Of the island's permanent residents, two workers are employed by Parks Canada—a parks coordinator and a parks facilities person. Their work two to four months on, two to four months off. Among their many jobs, they welcome visitors and researchers arriving on the south beach landing strip. A windsock flies from the Parks Canada truck and orange cones mark the runway. The other two year-round residents are employees of the Meteorological Service of Canada maintaining a three months on, three months off schedule.

Naturalist Zoe Lucas has called Sable Island home for decades and continues to provide invaluable information about its flora and fauna. She is most well known for her work with the Green Horse Society, which supports public education about the fragile nature of the dunes on Sable Island. She also writes books about the wild horses and helps filmmakers tell their stories with honesty and integrity, all the while respecting this most unique place.

🐎 *View from the southeast dune looking across Lake Wallace toward the Main Station, 1891. Both the dune and the lake have since been reclaimed by sea and sand.*

Trixie would be amazed at the modern comforts available at the new Main Station. No need to hang clothes on the fence, just pop them in the dryer. No need to shovel coal or split firewood for heat, just flip a switch.

In Trixie's day, glass bottles, cargo, or errant crates of fish thrown overboard from passing ships were exciting discoveries. Today, all manner of garbage, plastics, and flotsam washes up on the island, posing a real threat to Sable Island's flora and fauna and the natural habitat in general. It is a cause of great concern for those who strive to protect this fragile place.

Most people live on Sable Island for work, but often artists, writers, or photographers ply their trade there in the warm summer months. These days, there is no swimming in the lake, no skating on the ponds, and certainly no horseback riding. Sable Island is now home to the world's largest grey seal colony, but they are off limits to visitors as they can be vicious if threatened. No one shoots or harpoons them anymore—they are a protected species.

Trixie and her family would be surprised that Lake Wallace, their highway to the middle of the island, is no longer a lake. Shrinking for decades as wind-blown sand slowly filled it in, the lake completely disappeared a few years ago.

Trixie and her brothers would have welcomed the 1977 creation of the Sable Island Migratory Bird Sanctuary, which covers the entire island. Many species

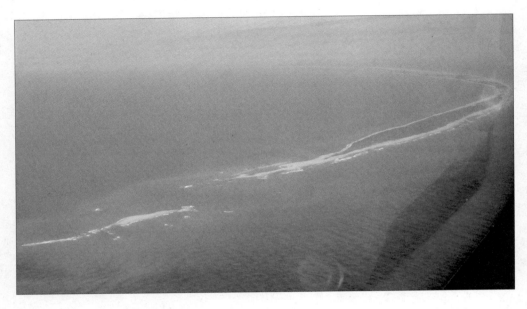

⫘ *Aerial view of Sable Island, August 2009.*

still stop by on their migratory visits or are blown in with storms, but over the past hundred years, the numbers have dropped drastically. Flocks of terns have reduced to about five thousand nesting pairs wheeling over Tern Pond, and no longer block out the sun as they did in Trixie's day. The little Ipswich sparrows, protected under the Species at Risk Act (2002) and the subject of many a scientific study, continue to breed on Sable Island.

Today, Sable Island's garden produce comes in frozen bags and is stored in the huge food warehouse just a few steps from the visitors' quarters. Visitors no longer have to worry about their lettuce heads or tomatoes brought over from the mainland going bad; they can simply pop them in the fridge.

No one cuts hay to feed the livestock or the tamed workhorses. Instead, residents can travel across the island with one vehicle of Parks Canada's fleet: one big green and white truck, one jeep, one Bobcat loader, two Gators (ATVs), and one Polaris. Walking is still the best way to really see the island, and the old cross-island paths are still visible thanks to the horses that regularly use them. No vehicle is allowed on the dunes.

But there is a great carpentry shop of which R. J. would be proud. There are tools in the shed to make or fix just about anything. Recently, a young researcher built a picnic table so everyone could enjoy lunch outdoors.

A tall tower rises above the new Main Station. Its principal job is to measure air conditions in the upper atmosphere and monitor the long-range transport

One of the telephone poles erected in 1885 now stands akimbo in the grass, July 2015.

of pollution aerosols. Atop the tower, a couple of obstruction lights punctuate the sky to indicate its location at night for any aircraft that might be in the area.

At either end of the island stand the old light towers, silent witnesses to a bygone era, their lights long gone. Ships now rely on satellite navigation systems to maintain a wide berth to the Graveyard of the Atlantic. The equipment may be modern and communication with the world instant, but when the sandy half-crescent of Sable Island appears unannounced beyond the plane's window, the mystery of its presence, clinging tenaciously at the edge of the Grand Banks in the North Atlantic Ocean, takes one's breath away.

AFTERWORD

It has been more than a century since R. J. Bouteillier passed his Sable Island keys to Superintendent Blakeney in January 1913.

Standing at the stern of the surfboat, three months shy of his fifty-ninth birthday, R. J. recalls the strapping young man who, thirty-four years earlier, made Sable Island his home. Now, with all of his children off the island seeking their fortunes—at sea, homesteading in Saskatchewan, as wireless operators in Nova Scotia and the Magdalen Islands—it's time to leave. He watches the green hillocks shrink in the growing distance.

Maestro Time lifts his baton and, with a flourish, brings it down to his stand. He taps once, twice. Strains from the French horns rise above the sand, heralding the opening measures of Sable Island's twenty-first-century concerto. The island song is both the same and starkly different.

Small ATVs, affectionately known as Gators, now race up and down the beach carrying young scientists to their work sites. Visitors must maintain a twenty-metre buffer zone from the wild horses. Flotsam of all varieties washes up on shore.

The sand still bleaches the eyes and the turquoise waves soften stressed hearts. The brave green carpet of vegetation waves in time to the unceasing winds. Sable Island persists.

And for everyone who loves this wild and mysterious place, who imagines walking its beaches and climbing its dunes, and speculates about the bravery of those early settlers, this book is for you.

ACKNOWLEDGEMENTS

I have my friend Rita Glen to thank for this project. In 2014, after three years of Sable Island immersion, I thought I was done with the sandbar for a while. But after scanning photos for my novel *Return to Sable*, she suggested I do a pictorial book with accompanying narrative. "You need to preserve this part of Nova Scotia's history for all lovers of Sable Island," she said. "Your ancestors were there at a time when there was little communication with the outside world. They were brave and intrepid ordinary people," she concluded with an encouraging grin. A year later, I submitted the initial manuscript of *Sable Island in Black and White* to Patrick Murphy at Nimbus Publishing. It has been well worth the long nights of sorting photographs, searching for and scanning documents, and selecting stories to share with my readers.

Stephen Ernst and Rick Penny, photographic restoration gurus, added just the right amount of contrast or removed glossy glare from photographs that couldn't be omitted from the book. Thank you for caring and for giving them a new digital life.

When I first met Emily MacKinnon, my editor at Nimbus Publishing, she was overjoyed that she had scored my pictorial book about Sable Island. She could hardly wait to read the first draft. Now as the final product gleams from shelves in bookstores, we can both reflect proudly on a job well done.

A huge thank you goes out to the Nova Scotia Archives for their help with scanning my great aunt's photographs, and to the National Archives for securing maps, photographs, and articles of particular historical interest.

Thanks to the Friends of Sable Island Society for supporting me in my endeavours to make Sable Island available and accessible to wider audiences. Since its inception in 1997, the Friends of Sable Island Society's mandate has always been to preserve the island by developing and delivering educational and interpretative programs. In 2015, the first ever Sable Island Conference was held in

Sable Prince, one of the stock stallions brought to Sable Island, was one of R. J.'s favourites.

Halifax. The two-day event brought researchers and authors together to deliver presentations on topics such as dune morphology, bird migration, seal and shark tracking, horse genetics, shipwrecks, island settlement, archaeology, oil exploration, Parks Canada status, and tourism just to name a few. The year 2016 marks the fourth year the Society has offered a one-thousand-dollar scholarship to a Nova Scotia high school graduate.

Thanks also to Anne Marie Richard, Roger Marsters, and Richard MacMichael at the Maritime Museum of the Atlantic who work every day on behalf of the people of Nova Scotia to preserve and share our rich maritime history.

After donating more than one hundred of my great aunt's photos to the Nova Scotia Archives, my mother, Lillian Beatrice Bouteillier, entrusted the remaining treasure trove to me. During this past year I have made digital copies so they will be available for generations of future writers, painters, researchers, and scientists. I am humbled and honoured to offer this collection to the people of Nova Scotia.

PHOTO CREDITS

All photos from the author's personal collection, with the following exceptions:

Alexander & Mabel Bell Legacy Foundation: 57, 58

Library of Congress Public Archives: 7

Library and Archives Canada: 56

Lisa Wright: 85

Margaret Pearston: 3, 54, 110

Maritime Museum of the Atlantic: 22, 24, 52, 87, and 104

Nova Scotia Archives: 4, 8, 14, 37, 38, 64, 68, 71, 88, 103, 106, and 107

Wendy Kitts: 114

William Inglis Morse Collection, Dalhousie University Archives: 9

REFERENCES

Appleton, Thomas E. "A History of the Canadian Coast Guard and Marine Services" (website), 2013.

Bouteillier, Beatrice. *Memoirs of Sarah Beatrice Embree (Bouteillier),* transcribed by Lillian Beatrice Thomson (Bouteillier), 1980.

Bouteillier, Robert Jarvis. *Sable Island Logs 1884–1912,* transcribed by Robert S. Bouteillier, 1967.

Beatrice Bouteillier Collection. Halifax: Nova Scotia Archives, 1984.430.

Bell Grosvenor, Melville. "Safe Landing on Sable," *National Geographic, Vol. 128, No. 3.* Washington, DC: September 1965, 396–431.

Bush Edward F. *The Canadian Lighthouse.* Ottawa: Parks Canada, 1974.

Canadian Geographical Journal, Vol. 4, No 2. Montreal: Woodward Press, 1932.

Dwight Jr., Jonathan. *Sable Island and the Ipswich Sparrow and its Summer Home.* Cambridge, Massachusetts: Nuttall Ornithological Club, 1895.

Farquhar, Benjamin A. *Farquhar's Luck.* Halifax: Petheric Press Limited, 1980.

Irwin, E. H. Rip. *Lighthouses & Lights of Nova Scotia: A Complete Guide.* Halifax: Nimbus Publishing, 2011.

McDonald, Simon D. *Sable Island and its Attendant Phenomena.* Halifax: Institute of Natural Science, 1883.

McDonald, Simon D. *Sable Island Its Probable Origin and Submergence*. Halifax: Institute of Natural Science, 1886.

McDonald, Simon D. *Known Wrecks on Sable Island, Second Edition* (map). Ottawa: National Development Bureau, Department of the Interior, 1890.

Macoun, John. "Sable Island: Annual Report of the Canadian Geological Survey" (website), 1899.

McLaren, Ian A. *Birds of Sable Island*, Vol. 31, Part 1. Halifax: Nova Scotian Institute of Science, 1981.

Morris, James Rainstorpe. *Sable Island Journals 1801–1804*. Halifax: Sable Island Preservation Trust, 2001.

Piers, H. "The Orthoptera of Nova Scotia" (website). Halifax: Nova Scotian Institute of Science, n.d.

Roscoe, Spurgeon G. "Camperdown." Sambro Head, Nova Scotia: unpublished material, 1986.

Roscoe, Spurgeon G. *Radio Stations Common? Not this Kind*. Sambro Head, Nova Scotia: 1986.

Rosebrugh, D. W. "The Graveyard of the Atlantic," *Canadian Geographical Journal*, *Vol. IV, No. 2*. Montreal: Woodward Press Limited, 1932.

Sessional papers of the Dominion of Canada: Vol. 3, First Session of the Third Parliament, 1874, xxiii–4.

St. John, Harold. *Sable Island*. Boston, Massachusetts: Boston Society Natural History, 1921.

INDEX

Page numbers set in italics refer to images.